F.M.R.L

Daniela Cascella is the most literary listener I know. In the frenzy of ephemera collected here, she catches echoes between films and philosophy, sculpture and drama, music and novels. Grounded in French surrealism, Italian narrative, and American poetry, *F.M.R.L.* auscultates books by some of the most magical writers from the past century: Clarice Lispector, Gert Jonke, and —above all—Michel Leiris. In the process, Cascella investigates the very logic of sound: its recursiveness; its decay; its interference patterns and resonant sympathies. Attending to the blur of voices into noise at the borders of understanding, Cascella gives back the songs of sound's extended techniques, transmuting noise back into poetry at the borders of these pages. *F.M.R.L.* is a *Passagen-Werk* of the inner ear.
Craig Dworkin, author of *No Medium* (2013)

In *F.M.R.L.*, each reader enters a different labyrinth. *Frictions, murmurings, resonances, laconisms.* Retune your listening. *Fractures, metamorphoses, residues, lingerings.* Reconcile yourself with the ephemeral nature of sound. *Fabulations, marginalia, recollections, labyrinths.* Revel in invention based on error. Daniela Cascella's *F.M.R.L.* is, to turn one of her citations into an emblem of her project: 'a site of confusion and heightened perception, a site of deep time.' Against the cognitive traps of syllogistic discourse she offers a celebration of the sundry accidents and errors of listening, each one an inspiration to write. She asks: 'And what shall I do with my heritage of listening?' I answer: 'Continue to share it with us!'
Allen S. Weiss, author of *Varieties of Audio Mimesis* (2008) and *Zen Landscapes* (2013)

This is writing in its most present sense. Writing that, true to its tense, enacts a continual process of thinking and perceiving. Writing that, spinning its words from sound, gathers up referents in a loose weave. Expansive in scope, and intimate in scale, this is writing where reading dwells in the reverie of detail—and deserves our full attention.

Kristen Kreider, author of *Poetics and Place* (2013)

F.M.R.L.

Footnotes, Mirages, Refrains
and Leftovers of Writing Sound

F.M.R.L.

Footnotes, Mirages, Refrains
and Leftovers of Writing Sound

Daniela Cascella

Winchester, UK
Washington, USA

First published by Zero Books, 2015
Zero Books is an imprint of John Hunt Publishing Ltd., Laurel House, Station Approach,
Alresford, Hants, SO24 9JH, UK
office1@jhpbooks.net
www.johnhuntpublishing.com
www.zero-books.net

For distributor details and how to order please visit the 'Ordering' section on our website.

Text copyright: Daniela Cascella 2014

ISBN: 978 1 78279 817 0
Library of Congress Control Number: 2014950440

A CIP catalogue record for this book is available from the British Library.

Design: Lee Nash

Printed and bound by CPI Group (UK) Ltd, Croydon, CR0 4YY

We operate a distinctive and ethical publishing philosophy in all
areas of our business, from our global network of authors to
production and worldwide distribution.

CONTENTS

Words viii

Foreword ix

Letters x

1. Dialogue of Sound and a Writer 1

2. Falling 3

3. Dark, the Dim Hear 6

4. These Sounds 9

5. S. 11

6. Borders 18

7. A Nosegay of Culled Flowers 32

8. Boxes 37

9. Leftovers: From the Notebooks on Writing Sound 48

10. Lakes, Sounds, Sculpture, Really 63

11. Inner Voices / *Sound* is as Real as *Hell* (after Dante) 68

12. Kinships 82

13. *The Record Itself Doesn't Matter* 91

14. Leftovers: From the Notebooks on Writing Sound 97

15. LISTEN 110

References and Credits 123

Selected Bibliography and Further Reading 132

Acknowledgements 137

Ephemeral. F.M.R.L. (frenzy-madness-reverie-love), a fame really, ever merrily, Effie marry Lee: there are words that are mirrors, optical lakes toward which hands stretch out in vain. Prophetic syllables.
Louis Aragon, *Paris Peasant* (1926)

This is the book of the great disorder and of the infinite coherence.
August Strindberg, *Inferno* (1898)

Given its contradictory properties, the most sensible approach to sound is through incoherence.
David Toop, *Sinister Resonance* (2010)

Sound generates the present from the memory of the past and through the anticipation of the future, but it is always now. To grasp this fleeting now in words and make it be significant... I need to find words that do not precede nor trace its passing, but generate it presently; and I have to prompt the reader to listen to the now of my writing with the same generative curiosity and unprejudiced desire.
Salomé Voegelin, *Sonic Possible Worlds* (2014)

I know a story about the desert, but only the beginning.
Werner Herzog, *The Enigma of Kaspar Hauser* (1974)

I have kept the following texts in one of the many folders that hold what I no longer know whether to call research notes, preliminary remarks, fragments, glosses toward a book, without being tempted by the possibility that glosses, fragments, preliminary remarks, research notes could in fact make up the book—its material and its form. As ever the quotes from artists and writers, as well as from other versions of myself, are in italics and not between inverted commas, to convey a smaller distance between texts through sustained proximity in reading: they present a merging and contamination of thoughts rather than any defining borders. My words—those words that I now hesitate to call mine, other than to think of mine as a site of extraction rather than a mark of possession—appearing before and after the quotes are not embellishments or comments, but records of a time spent reading, thinking, listening, rearranging and connecting more words around the vexed theme of writing, reading and listening. Three years ago I started writing a book around such a theme, taking those quotes as prompts; I then forgot about it and continued writing distracted from it. The following texts are the recording of a three-year long improvisation in writing, listening and reading: temporary arrangements of traces, clusters of recurring words and ideas, reactions, distractions, variations around a theme, false starts for arguments that recoil, whimsical thoughts with no claims to be taken too seriously, chamaeleoscriptures, beginnings, deranged essays, apparent documents of something that may or may not have taken place, texts as prompts for reading performances to be endlessly rewritten, remnants and purposeless records, possible notes and footnotes for a book that never was and that now is, albeit in a withdrawn form. And isn't Writing Sound always a note and a footnote anyway, with no claims for grand narratives, verging toward a receding horizon that will always be other, fleeting, transformed, ephemeral? Ephemeral, F.M.R.L: a flip from the immateriality of sound to the sounds of letters as material, a call from reading to voicing and sounding. F.M.R.L.: Footnotes, Mirages, Refrains, Leftovers of Writing Sound.

D.C., August 2014

F
Footnotes
False Starts
Frenzy

.

M
Mirages
Mine
Margins
Madness

.

R
Refrains
Records
Residues
Reverie

.

L
Leftovers
Listen

.

1.

Dialogue of Sound and a Writer

Two characters walking in a circle, anticlockwise and diametrically opposite

SOUND [singing along to the refrain of Flanders and Swann's *The Gnu Song*]: I'm s-s-sound. A most sinister s-sound...

WRITER [serious]: S-Sound? Stop and stop it, will you? We need to talk.

S [keeps singing and walking]: ...the sinister-est s-sounding all around...

W [exasperated]: How am I to stop you and address you?

S [patronising]: Writer, writer, it certainly is good to hear from you, but then again, you are good with useless things: words. You infect me with your generalisations: you call me Sound. You're asking the wrong question here.

W [dithering]: Are you not Sound?

S: I'm [pauses] s-s..., I'm eroded by your words and I vanish through time. Would you write this vanishing, instead of calling me Sound?

W [confused]: What does this mean, Sound? Are you speaking of a vanishing, or isn't it a making, every time you sound and every time I write after you? There is something ghostly as you take on acoustic features that are to dissolve and yet mark your being differently, every single time. So tell me, what are you?

S [whispering]: I am s-s... and infinitely less. Your words after me are approximations of nothing. I exist in dissolving and yet you write after me, away from me. The risk is to lose me...

W [hopeful]: ...the gain is to keep chasing you, along this circle, around and around. Yourself, do you ever feel lost?

S [sharp]: Sometimes I find mys-s in sounds I don't recognise.

And I keep moving! But listen, I have some advice for your fellow writers: tell them to stop discussing the absolute values of Sound, with difficult words.

W [disheartened]: But they will tell me that I'm ignorant and a fool, and that I blame their knowledge and discourse.

S [firm]: And you tell them, from me, they might be damned.

Long pause

W [sighing]: Tell me then, what is at the end of Sound?

S [furtive]: Perhaps, if somebody attempted to write my many contradictions, they might glimpse past my vanishing. Listen, and you will know you're being framed by my dissolving, and... you keep writing, don't you?

W [in the vain attempt to conclude]: Well what have been talking about so far?

S [ironic]: What talk? There has been no talk, we have sounded sounds. Nothing has been reported or documented, nothing. We've been chasing each other, sounding. You should not have called me Sound, but told me of the sounds in s-s, addressed me with incoherent stories and undecipherable acoustic traces, signifiers whose sense is uncertain and that yet mean. *Then* we would have had something to say. Think about it: Absolut Sound is a slogan to sell, a portal into emptiness and oblivion.

W [yielding]: No words, then, for and after Sound?

S: No words: your words are to be for and after s-s...ounds. [starts singing again; skips off the circle, laughing] ...Your sh-shifting words of s-s, round and round...

2.

Falling

A note like a minute that has to cross a century.
Henri Michaux, *On Music* (1949)

A string of clusters, one note only, falling, stubbornly hitting that note again, falling. At the end, after six and a half minutes: falling. A funereal fitful sequence of soundbursts, a cluster, a distortion, a soundburst, a distortion, a soundburst, forty-three times.

I am falling into Giacinto Scelsi's *Fifth String Quartet* (1985).

I am listening to a series of beginnings that curl back onto themselves and begin nothing other than a muted, repeated, flawed and ever-incomplete involvement with sounds.

* * *

Scelsi dedicated the quartet to the memory of his friend Henri Michaux after his death. As it marks an end it demands to listen to a series of beginnings that curl back onto themselves.

Scelsi and Michaux and beginnings and cycles mark the burning, frayed core of this book that only exists in its end as a series of beginnings—knots of inflections, tangents and horizons.

Following his groundbreaking work in 1948, *La nascita del verbo*, Scelsi stopped writing music: he wrote poems. He wrote poems after a music piece entitled *The Birth of the Word*. I take this fraught relationship between words and sounds, beginnings and breaks, as one of the prompts for these pages.

Scelsi, or: the spectral movements of sound as a whole of harmonic frequencies, some of which we cannot hear, some of which we do not want to hear, and that nonetheless constitute a

listening, even in spite of ourselves. Scelsi, who advocated the spherical dimension of sound and in the later part of his life chose to notate his musical improvisations by capturing them on tape—a flawed trace, the mark of a passing, the ephemeral nature of sound in spite of objects and supports.

* * *

The *Fifth String Quartet* unravels in change through repetition. The forty-three sound units are reiterations of the same gesture, a slowly decaying cluster that he once compared to the sound of exploding asteroids. As if we knew what that sound is. Because we don't know what that sound is. Because we can imagine how that sound might be and it doesn't really matter whether it was ever recorded or we were ever there.

Before this quartet—the reworking of an earlier piece, *Aitsi* for amplified piano (1974)—Scelsi hadn't written music for eight years. As I listen again, my attention steers away from any attack or origin: I only hear decay and transformation. Sound is sound as it comes into being. Sound is. You could listen—and in its ephemeral impossibility of being captured, writing begins. Like Scelsi's writing at the edge of absence of sound, yet resounding.

The quartet was written four years before his death, for a dead friend—an impression of sound into some place beyond, one last gasp. Many years before, in 1953, Scelsi had also dedicated *Five Incantations* to Michaux. Incantatory repetitions, dark passageways, titles such as *Wild and Strident, Slow and Mysterious, Supernatural*. What is this magic, this auditory sphinx that is often referred to in writing about Scelsi?

* * *

It was Michaux who wrote: *...to think it's a piece when it so happens you don't like pieces, but repetitions, long boring passages, just going*

my way, but there is no way, to return, to return to the same thing, to be a litany, a litany like life, to take a long time before the ending...

It was Scelsi who printed geometric figures in place of words, in his collection of poems *Cercles* (1986), forms with the impossibility of words of sounds yet sounding words nonetheless: *words always more obscure... more void... **the end**.*

* * *

At the end of these variations around a phantom, this book might begin.

3.

Dark, the Dim Hear

Pitt Rivers Museum, Oxford, 13 February 2014

Magic and trial by ordeal. A hand. Cast brass amulet, against the evil eye. From Naples.
The dim here always struck me. It's dark, the dim hear as I tentatively tune in voices and whispers from the past. The dim light in the museum, the amulets against the evil eye, the empty drawers under the glass cabinets prompt me to linger in the voids and in the gaps, to imagine and recollect gestures and rituals around them: they set up a scenario and make me step into a past, in the Seventies in Southern Italy, when in dimness of memory I hear, out of the hazy layers of my recollections I hear a grainy persistent breath, a fatigued whistlebreath emitted not as a sign of life, but as the last aural sign of a life about to expire, it is my great-grandmother in her bed, not because she is ill but because she is very old, slow, at the border of life yet clings to life, poisonous and persistent like ivy my grandmother would say, lying, breathing in a dark grey room at the end of a long Sunday afternoon, when dusk comes in, in my recollections I hear the dim, recall a persistent broken sigh in the shape of a breath and then a stop, a convulsive breath and a stop, as if a rusty hook had caught that breath to prevent it from expiring, and she lies in a tall bed, maybe tall because I was little, although I later learned that beds at the time were in fact taller, I hear that convulsive breath as coming from an underworld of hidden whispering galleries, it is my great-grandmother's but to my hearing it sounds as if it is the whole room breathing, and I'm left there, I can barely see her but I hear my larvae-great-grandmother disappear into her broken sigh, sighing herself into the room.

Other voices are plotting next door. For some days I have been weighed down with a persistent headache and sickness. They bring her a small bowl full of water and a bottle of olive oil. She pours some drops of olive oil in the water and begins to hum, hums, a circling incantatory spell begins to coil around my hearing, then out of the bundle of bed sheets a tiny hand appears, withered and wiry, shadowed by wrinkles and by time, as she repeats small circular motions on my forehead with the tip of her thumb mumbles mumbles, I'm unsure if she really means anything or if she is just repeating a gesture passed on to her, soiled and half-broken, across who knows how many generations, I'm unsure whether to laugh at all this or be very serious and solemn, I am here little I listen but I don't know what's going on and maybe I'm not supposed to. Why is everyone suddenly so serious and solemn. Many years later I learned, in a car at night, speeding past the streetlamps at the edges of town where rubbish heaps, half-built tower blocks, concrete walls taken over by ivy and nettle bushes hide another past and another layer underground, past one of the few surviving mythraeums that nobody ever stops to visit, the light and speed and summer air taking my breath and absorbing me in that uneven mix of ritual and disillusion, of life expiring and ritual dying, of spells persisting yet changing, it all came back to me in a flash, ferocious like the heads of pigs hanging in the windows of a butcher shop to point at its deathly sales, a glimpse of something recalled in a splinter of a moment in transit, ferocious because it was her last spell before her death, later I learned I'd been subjected to a spell against the evil eye.

Votive offerings

I give you an ear because you saved my ear.
I give you an eye because you saved my eye.
I give you a leg because you saved my leg.
And my foot. And my torso.
And my heart.

But what would I give you if you saved my voice?

4.

These Sounds

The only information on these sounds I had from Stephen was: *The CD is called* Music for Earbuds *and is composed entirely from headphone feedback which makes some surprisingly organic (as well as electronic) sounds.* I spent the following week dwelling on these surprisingly organic sounds as I imagined them, before even listening to them — or maybe I had begun to listen anyway. I have a habit with listening. When I hear of a record or sound piece before I hear it, I anticipate and deliberately infiltrate my experience and memory of it. Call it an exercise in fabulation, an investigation of the tangles in the listening-writing space, or simply the will to prove that a sound is never a self-standing entity but is connected, haunted and contaminated by its listeners and their histories. So here I am, skirting the edges of these not-yet-heard sounds, listening to, listening in, but always out. I have a habit with listening, it responds to titles before I listen, or maybe because I have always been listening. *Music for Earbuds...* Ear, buddy! *Who's out there?* Sound it again, please? Who's that? *Hear!* I have a habit with listening. It makes me write even when I don't now what to say, and today after playing over and over these sounds at last, I write: ringing buzzing these sounds spiralling frenzy. These sounds so stark and stubborn, hit against their form, I slide on their surfaces. These sounds so alien yet alluring call me to spend time with them, attend to them. These sounds mark the edges of hearing and understanding. The rest will remain a mystery, this ring buzz these sounds spiral frenzy. I have a habit with listening and sometimes it's obsession. These sounds take me to the edge of understanding. The edge here is the ear that hears. My listening encounters nothing but itself in these sounds. There is no key into or out of these sounds,

only the endless play of their fabrications. Shatter any notion of sound as signifier. If I had to name these sounds it would be something wild: an incantation that returns and turns and generates a new meaning in itself, like these sounds. Why am I listening to these sounds? Because they're there, and because they're there I want to explore them and as I try, I fall into the circle of these sounds as I fall into the circle of myself. This circularity has no claims, it bounces the responsibility of listening back onto me. And I haven't even started telling you of the void these sounds are set against. This void behind these sounds resounds my fluttering thoughts, terrors of understanding, interpretive delirium: Listen to the tweeting of the mechanical bird, listen to *The Inner Dialogue of the Lonely Mechanical Bird.* In their exaggerated detachment these sounds mock the easy, dangerous assumption that a recording is *true*: maybe, maybe there is a mechanical creature, somewhere in my thoughts, that thankfully does not have to be true to be experienced. I spend a good half hour contemplating this creature spawned by these sounds, crazed wind-up-toy running in circles. Its tones, sharp or rounded, puncture my understanding with their presence. The tangibility of these unnameable sounds. Is it a trap? Even the sounds of my keyboard as I type against these sounds, sound more terse and metallic. Today there's three of us and it's a crowd: myself in the room, the headphone on and in my head, the mechanical bird with its metallic peal in my mind. These sounds. At the end I realise I might not have written much about them. I was too busy listening and writing these sounds, in, but always out. In my brain and on this page they stay, at peace until they'll reawaken to the next obsession. Go, listen yourselves. I told you I had a bad habit.

5.

S.

An artist we might call S. digs in search of a way of presenting her sculpting. Not only is the digging metaphorical. She actually digs holes in the ground, leaves huge heaps of earth all around them, and records the sounds of these procedures—partly to fill the emptiness of explanation, partly to make sure that a trace of her sculpting remains: a sculpting, not a sculpture. In matter she digs. In matters of words, she admits to a tendency toward broken utterance. Her choice of speaking in half-finished sentences embodies a form of resistance: not against speaking in itself, but against a canon of speaking. Her words are like those heaps of earth: a layered mass, and then they crumble. On a rainy morning in Bergen, Norway, she once showed me pictures and played sounds from a recent sculptural installation with the holes and the heaps of earth. I remember: a conglomerate of screechy and muffled noises, heaps of earth probed by long mechanical sticks, and a sense of scale that overwhelms the human yet is tentatively measured by it; rawness of materials, punctured by a sharp sense of observation, fullness of materiality, corroded by thought processes that are as ephemeral as present.

Where present? In those sculptures I might never reach? In the space of S. and myself talking, looking, listening? In the work enmeshed in a web of connections always recalled, always shifting? It would be silly to think that all of these talks and thoughts and considerations will not enter my experience of the work, even if I don't get to see it. Since I saw the pictures of those heaps of earth, and heard those primordial sounds, I've been haunted with the presence of those holes and heaps of earth cut through or grazed by mechanically-operated sticks. The pictures that S. showed me are dark and dense and layered, like her

broken-up words. I wonder if it is pictures of her works that I saw, or charts of geological strata, muddy and thick. I find myself inexplicably drawn to those dark and muddy conglomerates— not sure whether this is because of some inherent quality they have, or because they remind me of a past, much more primitive and compelling space, a call from afar. Or maybe because the installation is entitled *Writings*.

* * *

S. and I talk of caves and the storage of knowledge for three whole days of rain, we talk, the rain like a grey soft blanket, three days curl themselves against the black rocks of Norwegian dark mountains, into each of our darknesses. The night outside, congealed. The grey soft blanket, no longer thin and fluttering, descends to enclose the world it once concealed in a web of darkness. It seems to me there should be a shape for these hidden processes, a shape formed out of our caves and that earth, and the sounds in and out of those caves, before the grey soft blanket covers it all again. It's time to go before the crystal-clear surf of thinking returns to wash these words away or tidy them up... It's time to go and our journey involves mud, matter, shades...

...and a tendency towards incoherence, which I find enjoyable. Infatuated with whispers, we speak and continue to dissolve in this twilight of matter. A little more intangible every day, and then we can no longer understand those caves, the sounds out of them or the simplest tune, or sculpting or writing any longer.

Back in London a few days later, I receive an email from S.

7 May 2013, 15:58
Do you know these words by Hannah Arendt? "Although the living is subject to the ruin of the time, the process of decay is at the same time a process of crystallization, that in the depth of the sea, into which sinks and is dissolved what was once alive, some things

'suffer a sea-change' and survive in new crystallized forms and shapes that remain immune to the elements, as though they waited only for the pearl diver who one day will come down to them and bring them up into the world of the living—as 'thought-fragments,' as something 'rich and strange,' and perhaps even as everlasting Urphänomene."

I think we are pearl divers too.

* * *

Crystals, mud, pearls, conglomerate. And their ephemeral counterpart. On the same day, I read some words by Robert Smithson, from 1969: *It is the dimension of absence that remains to be found.* Ten years after these words, Ana Mendieta found this resounding absence in one of her *Siluetas,* when she outlined her figure in a space initially carved out by an animal. I write to S.:

7 May 2013, 19:54
Can we cover our words in mud like Mendieta, at once be present, and be cavity within cavity? What do we make of all these trips to the catacombs of our selves? Can I whisper to you: the empty caves in your work swarm with senses although they might not make sense? Your sculptures are not there as objects, those heaps of earth are Siluetas Sculptures Silurian, Silurian that period in the Paleozoic era when plants began to appear on earth, over 400,000 years ago... Silurian Silence. Forty years after Mendieta, the dimension of that absence still resounds, we have found it, and now we think of storing it, in heaps of earth and thoughts out of amalgams of words. Not in easily transportable or graspable objects and syntax, but something more vast and elusive. A fleeting yet material sculpting-writing, where words do not perform a function, but make a place. This is how we build our language.

More words from S.:

8 May 2013, 8:14
Caves have always been places for rituals. I often choose caves to do my recordings. I connect them to a sensibility for places, surroundings and things; for the places within things. I gain knowledge through listening to sound and its resonance in matter, through the sensing-knowing-understanding part of the brain. I find this material memory and interwoven concepts useful to talk about my work. If you make a sculpture, then there is the object that you make. But there is also the ritual of the making. Does the non-technical part generate as much material memory as the technical part? How can you preserve that kind of knowledge, not pronounced, but experienced?

Again, I think of those pictures so dark, remote and obscured by long accumulations of time. S. refers to her ongoing attempt to keep intangible things, processes, memory, without the thing. By contrast, I am led to considering the thing, without memory: in March 2013 I visited the *Ice Age Art* exhibition at the British Museum. I recall *The Lion Man*, from the Stadel Cave in the Hohlenstein mountain, an ivory sculpture dating to around 40,000 years ago. It presents a man with a lion's head. I cannot even figure the meaning of 40,000 years ago: in time it is abstract, in matter it is close. The fascination with these objects is: there is hardly any knowledge of what their function was. Better then to stop thinking about function altogether, better focus on the pull toward them instead of the reason of that pull. In a series of texts and lectures following the discovery of the Lascaux cave in 1940, Georges Bataille makes crucial points about our fascination with primitive art, art from afar: we cannot even start to connect with these artefacts, he says, if we wonder about artistic intentions. He urges to consider instead the feeling of their *burning, fiery presence* that strikes us. To reduce these objects to what can be easily

explained with language, and to what can be understood about value, is to ignore the art. Such apparitions (apparitions, not objects) do not designate *this* or *that* as a thing, but the tactile motions and the feelings of those who made them. The execution of the carving was part of a ritual of evocation/apparition, the resulting objects did not have *meaning as permanent figures.* Keepers of what is forgotten and hardly possible, once they are displayed they are misread as representations of something lost, their materiality is mistaken for beauty, authenticity, origin. What gives them such charm though is the negation of their durability. As they reach out to us across the millennia as objects, they merge the confusion of a past with the clear evidence of how every present is endlessly relayed unto us in metamorphosis, endlessly changing yet familiar. Perhaps their final appeal is for us to cease to aim at being *clear and distinct.*

Another darkness from another cave. The image of the tapping stick shown to me by S. is inspired by the myth of Persephone as described in a handful of verses, that she wrote to me in another email and whose origin I could not trace: *The lord of the underworld, in an attempt to understand the world above but blinded by its light, hits everything on his path. He makes things resonate to get familiar with them. Tapping sounding an attempt at knowing*:

In a black chariot, behind black horses
The Lord of Terrors
Thundered up
To survey the roof of his kingdom.
He scrutinised the island's foundations,
Double-checked every crevasse, crack, fault,
For sign of a shift.
Probed every weak spot with his sceptre
Tapping rocks and analysing echoes.
Everything seemed to be sound.

End. A Literary Muddy Conglomerate.

W. G. Sebald quoting Jean Starobinski on the crystal: *You cannot tell whether it is a body in its purest state or, by contrast, a petrified soul.* In vitrification body becomes pure substance no longer concerned with the ephemeral. Louis Aragon on the ephemeral: *Ephemeral. F.M.R.L. (frenzy-madness-reverie-love), a fame really, ever merrily, Effie marry Lee: there are words that are mirrors, optical lakes toward which hands stretch out in vain. Prophetic syllables.* I half-remember then. *If I were a ghost,* this is the cave to which I would return. Tonight is a limit, intimate and pointing afar backwards and forward. But where am I? With S. there is another S., in Bergen tonight, another Bergen. Listen S., we stand in the midst of a porous underground edifice, and the thought comes to us, through us it comes patched invisibly, patched away at the last membrane and the world, a milli-crystal, shot up, shot up. Nights demixed. The world put its innermost reserves into this cave. Here we are waiting, waiting as there was behind this rainy drift and dream-anodyne of haze, another sculpting and another diggingwriting in another Bergen, *Bergen now veiled, now vanished, now crumbled, now fallen,* behind haze and rainy drift of dream-anodyne, in our foreign backgrounds of muddled words, there is another sense for foreign, another realm of sculpting digging writing to be apprehended with the senses only, a mine, mind, a stream in this cave, and I remember your name tonight as it writes itself in my lucid recollections and your name is Sign.

for Signe Lidén

6.

Borders

My case, in short, is this: I have lost completely the ability to think or to speak of anything coherently... My mind compelled me to view all things occurring in such conversations from an uncanny closeness... For me everything disintegrated into parts, those parts again into parts; no longer would anything let itself be encompassed by one idea. Single words floated round me; they congealed into eyes which stared at me and into which I was forced to stare back— whirlpools which gave me vertigo and, reeling incessantly, led into the void.
Hugo von Hofmannsthal, *The Letter of Lord Chandos* (1902)

What can I do?
One must begin somewhere.
Begin what?
The only thing in the world
worth beginning:
The End of the world of course.
Aimé Césaire, *Notebook of a Return to the Native Land* (1947)

A sigh runs through the audio track of this film like the segmented parting line runs through the highway track on the screen, both relentless in their fractured rhythm. It gasps for a few minutes then streams into a muffled song, but all I hear into the song is the sigh. Myself listening, the sound of gasping, and Nat King Cole, the three of us singing, sighing, sing-a-sigh-ing along the way and along the highway. That sigh is around the space of my hearing, it turns it upside down. It reaches out through slanted lines of understanding, its sound gasped over to me. It won't stop, it encloses.

18

What are we talking about? What are we talking? I hear a song:

The night is mighty chilly, and conversation seems pretty silly, I feel so mean and wrought, I'd rather have the blues than what I've got, All night, I walk the city, watching the people go by, I try to sing a little ditty, but all that comes out is a sigh.

The opening titles in the opening sequence of the film draw a liminal inverted space of motion and transition. They cut the screen diagonally and appear in reverse order:

DEADLY
KISS ME
ROBERT ALDRICH
BY
PRODUCED AND DIRECTED

The opening sequence of *Kiss Me Deadly* (1955) draws lines of escape; it is a border that tempts to be passed and trespassed, across territories of unstable understanding and illegitimate kinships. Like any attempt at writing after listening, it prompts me to think of the oscillations within and without myself as a subject of sorts, moving to and fro across borders inhabited by different voices.

A nonlinear sequence of events ends in the film at its very beginning: the mysterious lady in the white mac is murdered after a few minutes, just when we started being seduced. Across the borders of listening the episode brings in more voices, and sighs. The surface of the opening titles, arranged diagonally, cuts through the vertical flat screen and through sigh, song, words and breath it draws me in. It's not just Nat King Cole's voice from a radio, heard alongside the opening titles: it is that voice with that heaving breath and the diagonal words as blades. This is far

more devilish than the voices from the other side transmitted through the radio in Jean Cocteau's *Orphée* (1950), much less arty and conscious: *Kiss Me Deadly* is a film with a bomb after all, by that master of deception, gritty plot and inversion, Robert Aldrich, who nine years later, in *Hush, Hush, Sweet Charlotte* (1964), led us to believe we'd heard the devil in Bette Davis' crooked voice and instead voiced the devilish through Olivia de Havilland's poised and controlled delivery: there is not much underworld here, rather, the other world is on earth, in screams, whispers, thunder, hush, hush.

The other world comes up and pervades, we invite our lost ones over here, on our highways. We sigh, run, and pass away with them. At the end, sometimes they listen, across a screen, they listen, through speakers, they listen—like Nastassija Kinski in that revelatory moment for Travis in Wim Wenders' *Paris, Texas* (1984), the end of a highway loaded with saturated sunset candy nostalgic colours, in the darkness of a booth, the same saturated colours reflected in the decor and in the punchy pink of her jumper, looking at nothing across the screen, looking at us, talking to somebody whose face she cannot see, speaking:

If, er, if there's anything you want to talk about, I'll just listen, alright? I'm a real good listener.

The voice, recorded and transmitted, the sound of the sigh of the listening woman, present and cyclical. Every beginning a sequel each beginning a sequel equel quel uel el l. Contingent cyclical logic in the space of listening, repeat this and repeat. Here I am to begin, in a beginning cyclical. Sometimes I forget how to recall each contingent cyclical beginning. So here I am musing over the assonance of sequel and cyclical, can I begin by imagining a cyclical sequel, can I write and rewrite this sigh and this song and this listen as a cyclical sequel? In all this I become, sequel and cyclical: quizzical. I once heard there is cyclical logic in the space of repeated listening. It takes effort to understand, it takes effort to understand why there is cyclical logic in the space of my repeated listening, and here I am musing over the sequel and the cycle. Every beginning a sequel each beginning a sequel equel quel uel el l. Contingent cyclical logic in the space of listening. Listening closer in each beginning, we may never comprehend the source of the sounds within us, oh, so contingent and cyclical. You must not listen closer, you must listen distant, far away, distracted. Then you might discover these sounds. Did I ever mention there might be cyclical logic in the space of listening? Will you ever discover that you must listen distantly, to discover these sounds? Every beginning a sequel a sequel equel quel uel el l. I find these sounds again in sequels cyclical quizzical c y c l i c a l q u i z z i c a l c y c l i c a l q u i z z i c a l...

Running and running and looping, for months I have been cut through by voices and words that often lose their grip, that point beyond the borders of themselves at lost aural horizons looped, deranged. Looping reading into listening into writing across discontinuous and spurious materials has filled my otherwise empty time, the time emptied of meaning when, coming back from yet another conference on sound, I would feel like I no longer knew how to speak, listen or write. Truly I have been: empty, devoid of words, yet full of longing for them. I have tried to think through this emptiness, whose inherent longing has filled my reading. Did I need the barren scenario so as to receive, to be filled again with words and then to become, again, empty, unable to read them as permanent markers and yet, longing to write impermanently?

So I've been writing words that do not explain: only fall out of their borders and expire, like those sighs, slanted, like those titles, unable to be read as fixed markers and yet—I am longing to write and keep writing, in change. Like the car at the beginning of the film at the beginning of this chapter, words run away, they point to a fugue. What's left is a knot of intricacies that belong together but I cannot plan or explain, just hand over to you.

A film frame from the beginning of David Lynch's *Lost Highway* (1997) shows the buttons on the intercom in Fred and Renee's doomed house:

LISTEN - TALK - DOOR

I listen between talk and door. My attention dwells on the peripheral—accidents, detours of thoughts—rather than any assumed core, up to the point when the very core of listen-ingreading-into-writing becomes what is normally deemed peripheral, outside talk and outside door. I seek to reclaim the intermittent incoherence in listening as it urges to move through its residual presence into a marginated writing that is not a site of clarity but edge, horizon, fugue.

In *Lost Highway*, with more than one nod to Aldrich's noir *Kiss Me Deadly*, Listen-Talk-Door marks a passageway toward the end of the world or an end of a world, and in turn loops into a beginning. It opens to lost highways in one film, or, a portal toward another world and another end, or reversal of doubles. They end at the end of the world up in flames.

At the end of *Kiss Me Deadly* an explosion is caused by the film's whatsit, a suitcase containing a bomb that wreaks havoc and brings about destruction, a whatsit that none of the characters will ever hold—like sounds before words. The sounds, blips and hammering beats, the flashing lights throughout the whole sequence of destruction reappear in *Lost Highway* filtered through Lynch's distorted eyes and ears: drenched in red, heavy, punctuated by the pounding rhythm of Rammstein's heavy riffs; the whatsit here though is not a tangible object but a vision— mirage, anticipation, recollection?—of a place, a reversed sequence of an exploding cabin in the desert, as the flashing lights in the corridor frantically channel the dreadful whiny questionmoan of Alice asking: *Why? Why?*

Why? Words after explosions of meaning, end of the world, words on edge, words at their end, after sound. The unstable hesitant status of words in front of sound. Think of sick words, schizophrenic words, words stuck on a groove, locked, aphasic words, speechless at the border between themselves and what exceeds them. Words at the end of their world, in front of sound, dispossessed. Words in front of their sonic doom.

That's all words they taught me, without making their meaning clear to me, that's how I learned to reason, I use them all, all the words they showed me, there were columns of them, oh the strange glow all of a sudden they were on lists, with images opposite, I must have forgotten them, I must have mixed them up, these nameless images I have, these imageless names, these windows, I should perhaps rather call doors, at least by some other name, and this word man with is perhaps not the right one for the thing I see when I hear it, but an instant, an hour, and so on, how can they be represented, a life, how could that be made clear to me, here, in the dark, I call that the dark, perhaps it's azure, blank words, but I use them, they keep coming back, all those they showed me, all those I remember, I need them all, to be able to go on, it's a lie, a score would be plenty tried and trusty, unforgettable, nicely varied, that would be palette enough, I'd mix them, I'd vary them, that would be gamut enough, all the things I'd do if I could, if I wished, if I could wish, no need to wish, that's how it will end, in heart-rending cries, inarticulate murmurs, to be invented, as I go along, improvised, as I groan along, I'll laugh, that's how it will end, in a chuckle, chuck chuck, ow, ha, pa, I'll practise, nyum, hoo, plop, pss, nothing but emotion, bing bang, that's blows, ugh, pooh, what else, oooh, aaah, that's love, enough, it's tiring, hee hee, that's the Abderite, no, the other, in the end, it's the end, the ending end, it's the silence, a few gurgles on the silence, the real silence...

After reading Samuel Beckett's words in *The Unnameable* (1953) I turn to two more books: the former is *De l'angoisse à l'extase: Étude sur les croyances at les sentiments* (*From Anguish to Ecstasy: A Study on Belief and Feelings*, 1926) by Pierre Janet, the French psychologist and philosopher who pioneered studies in the field of dissociation and traumatic memory; the latter was written by the Italian ethnographer and historian of religions Ernesto De Martino and never published before his death in 1965. It is entitled *La fine del mondo* (*The End of the World*, 1977) and it appears as an unfinished, unedited collection of fragments summing up to a comparative study of the idea of apocalypse interrogated through its manifestations in psychopathology, ethnology, religion, philosophy and literature. I first encountered Janet's book quoted in De Martino's—a book about the end of the world containing a book about people at the end of their senses and with no more grip on language; an unfinished book of fragments and a book containing words by people dispossessed, words that exceed themselves. *I heard that, and it sounded like the end of the world... Everything in me is a dead letter, I am no longer a woman with a heart, somebody else's soul is lent to me, I am nothing but a poor puppet pulled by strings all over, my soul is stolen, for every speechless moment there is somebody else I belong to, and who moves my actions and my thoughts. I hear myself speak and it is somebody else speaking, I am surprised at replying the words I reply. I am dragged.* I later found out that one of Janet's patients had been Raymond Roussel, who wrote *Impressions of Africa* (1910) and *Locus Solus* (1914) following formal constraints, deploying puns and homonyms. I'm tempted to follow this thin yet persistent trail, from somebody possessed with words to a study of words by dispossessed people, to a constant spinning and reinvention of words against an apocalyptic scenario. In these books I read words that have lost their sense and their bearing yet claim to be heard; detached from any supporting meaning, they constantly remake meanings. Reading De Martino's enquiry into truly

visionary examples of what he calls *loss of borders and horizons,* again I question language at the edge, dispossessed words against a horizon of void. Words coiled up on themselves, words after sounds that allude to a meaningful absent: troubled, they point at something else but are uneasy with regards to the shape and movement of that *at.* It is either too much or not enough for these words devoid of any domestic safety: void beyond in the former case, loss and rigidity in the latter. It's difficult to operate through them. Either sound is too far and leaves words in a void intimacy, very private but inexplicable and frozen, or it breaks in and leaves no chance. Hence their meaning can only be delirious: not immediate or most obvious. What, how to write in front of sound?

Sonic Doom

Between euphoria and dysphoria, I can write: histories of listening into reading into writing and back. Beginnings that begin nothing, like the film clips and texts that have appeared so far on these pages; beginnings that spin, ritualistic returns, wavering motions of meanings weaving a dark underlining that troubles and moves them, a conglomerate in transformation and change.

A sinister non-domesticity inhabits them. What allows to go through and across them, is listening and reading: not sound or text as fixed entities, but listening and reading as activities in change and in time.

I write these words as they lose their connections with habits. I write them as I read *Água viva* (1973) by Clarice Lispector:

I am not transmitting to you a story but just words that live from sound.

I'll keep talking to you and taking the risk of disconnection.

I don't want something already made but something still being tortuously made. My unbalanced words are the wealth of my silence… I write because I so deeply want to speak. Though writing only gives me the full measure of silence.

Let these words: curl, wither. Let them be heard in their thinning. Let me syphon them boney, let me drain them until a skeletal presence is left, no tomes, no weight, only necessary filament-words to creep up and haunt the secret thickness of thoughts.

I no longer write much and sometimes I no longer write. Because I could not be clear I got here. For the well-determined minds I descended and drowned in the waters of wordy. For the well-determined thoughts I drowned in the narrow well of linear. Determined by their thoughts I drowned and descended. The well-determined mind, the consequential. The, well, determined wordy mind that overwhelms. Well determined wordy linear writing, when my words began to find their withering ways I would stare at the knots on the page and think of you. What great conviction, what clarity. I was repelled into silence. And what did I do when aphasic temptation came?

What I did: I received it, as it silently moved subterraneous and eroded these words.

I hear words at their end in songs at the borders of understanding.

I hear them in nonsensical fragments of syllables, sounds at the borders between language and animal verses, words petrified, starched, stuck in stubborn static rhythm, the stubborn rhythms of mutilated words in the songs by Tenores di Bitti, the Sardinian polyphonic singing group whose style dates back to thousands of centuries BC, whose origins remain unknown but are thought to have generated in the solitary life of peasants and shepherds mimicking the sounds of sheep, cows and wind—an array of guttural sounds, overtones and nonsense syllables that have often sounded in my ears as stuck, ossified versions of the Beach Boys' polyphonic arrangements circa the *Smile* sessions. Try and listen to them, one after the other, forget about genealogies and canons, listen to those vocal intertwinements and rhythmic mosaics.

* * *

I hear words at their end as I reach one end, rewind back and think of another fugue, or an artist whose work was in fugue, Arthur Russell and his sounds and words on the border of another thought, *things I can't see, matters lacking forms.* When I interviewed one of Russell's long-time collaborators, Ernie Brooks, he told me of a day when Russell, surrounded by a forest of audio tapes hanging down from the ceiling in his studio, played to him a version of *That's Us / Wild Combination* with so much echo that you could no longer single out a sound. He said: *Arthur believed that if you could not hear something as a finished form, then you could really hear it as you imagined it.*

* * *

I hear words at their end in another voice, Walt Whitman's at the border of his life, in one of the very last poems at the very last end of the deathbed edition of *Leaves of Grass* (1982), still lacking words, *The Unexpress'd*, beginning with *How dare one say it?*, flying over, in a handful of verses, the history of poetry and sounds, and ending: *After the countless songs, or long or short, all tongues, all lands, Still something not yet told in poesy's voice or print—something lacking, (Who knows? the best yet unexpress'd and lacking.)*

* * *

I can finally hear the thread that binds all this, away from linear explanation: eerie mysterious words are half-sung half-spoken, in a thread mixing circularity with frayed echoes, spinning motion and fleeing song and breath, like the enigmatic singing of the old, barely human creature at the beginning of Akira Kurosawa's *Throne of Blood* (1957), spinning a thread, norn rather than witch, her chanting slow, hypnotic, circular and able to suspend gaze and hearing in a stupor of sustained stillness, an echoing space, not empty but resounding.

7.

A Nosegay of Culled Flowers

A spaghetti version of Robert Duncan's *The H.D. Book,*
Book 1, Chapter 1

A lullaby emerges in my memory in the shape and sounds of a staggering procession of words in a dialect from Southern Italy, whose sense for me is almost entirely lost. On a plaintive melody it tells the story of a wolf eating a sheep and it then precipitates into a tangle of words and expressions obscure to me, but that have been returning in the circular space of my inner singing throughout the years. Why did my grandmother sing that lullaby and put my brother and myself to sleep, her story leaving us utterly terrified although captivated by its melody? I begin to sense an older history unfolding, a voice calling from a past more remote that my lifespan, not understood but heard and felt, and passed on to me through the voice of my grandmother. No longer just private or personal, that lullaby belongs to a dissolving yet collective culture. Made present and alive in my experience of hearing them read aloud, all the words and sounds kept in the archives of memory and its silenced collections dissolve, unless I voice them or allow their voices to pulsate in me, when I listen and read and write.

Those words in the lullaby reached me although I could not read their text. I try and recall them again, hearing in the connective space of singing a subtle persistent echo that I could not otherwise hear in myself detached, or in the words detached. That lullaby, and later on many more words and sounds and songs, pointed at another way of listening, different from the prescribed one found at school. To paraphrase Robert Duncan's encounter with the poetry of H.D. narrated in the first chapter of *The H.D. Book,* those sung words did not belong to public estab-

lishments that a well-educated person should know, to measure and value their worth in the marketplace of cultural industries. To listen to that song, and many others to follow, belonged to the inner life or, as W. G. Sebald once wrote, to *the dark inner lining* of reality. They did not call for a crystal-clear system of analysis, or for deciphering. Still today, those voices want to be heard, not to be deconstructed; they want me to say, *I want to be here with you* — and then, I want to write: an act of volition that brings all those voices together: a leap of faith. In listening I see the shades before this leap of faith, generating precarious alluring constructions. In writing I hear the echo of doubt in each beginning, from which my words—and I with them—cannot be healed. Although drenched in music, art, poetry, those words and voices have visited places and touched people who stray from what's commonly regarded as 'art'. They do not have much to do with the reassurance of knowledge or skills: they point at the resonance heard, early in life, in certain sounds, in a strong sense of kinship across time. I want to reveal this kinship, even in the apparently most-known of sounds, and songs: to voice the inner lining of what might be taken for granted. To keep alive the voice of that poem and that lullaby and many others; their sense of necessity, their presence. When I heard my grandmother's voice channel words whose sense was lost but whose sound spoke, I heard them in a place constructed in proximity through an aesthetic experience. Today I know that those verses and songs were not there to be summed up: I was to construct them again and again every time I wrote about them. What I got through listening did not pertain to ideas of permanent, awe-inspiring public heritage: it belonged to a history of sensing and under-standing, private in its making and public every time I reached out through writing.

When I play that lullaby back in my recollections, it crumbles into the time of now. It is not attached to a specific place or state of mind: it shapes my state of mind and place today, not as an

immutable record: it sheds a different light on what is around it and around me every time I hear across it, in change, woven across the mutable connective tissue of experience: not as a still presence but a mutable entity that allows me to slide into the space of fictions, changes, questions.

I'm interested in the shift from real to fiction and the sliding back from fiction to real that occurs every time we are confronted with aural memories as escapes out of fixity: the fixity of the edge of the ear, the illusionary fixity of a support. What is around them, life, erodes them and transforms them. They prompt rather than document, they prompt not to classify, but to interpolate. No aural memory can coincide with the event of each experience of hearing. They are not time-capsules-on-demand. We live and listen with them, not because of them.

Again I go back to that lullaby, it was sung to me by my grandmother, in Italian *nonna*, it went *nonna nonna nonnarella*, it was sung by nonna-nonsense, nonna-sense, and lullaby is ninna-nanna, nonna-nanna, nonna-nenia, nenia is dirge, incantation. Nonna-norna norn. The norns, in Greek mythology, are the *spinners of the thread from which life is woven, they measured each person's lifespan and cut the cord to deliver them into their death, as once they had cut the first cord or chord: when the thread began when sound began.* In tune a thread unravels in life, measured by its pace within a recalled lullaby. And the thread of a life is also the thread of an argument. Duncan reports how in 1891, a month before her death, Madame Blavatsky closed her last essay with a quote from Montaigne: *I have here made only a nosegay of culled flowers, and have brought nothing of my own but the string that ties them.* Duncan writes of this string as *the thread of her argument, a wish that she, and mankind with her, might be released from the contradictions of dream and fact, creative idea and actuality, that tortured her spirit. But the string was also the quest for the end of dream, creative idea, volition — if only they could be proved to be their opposites...* So I think back of my attraction to my grandmother's voice in that

lullaby, as I weave the thread of my voice and my words and many more into its words and into Duncan's words, and begin to see the string of my argument at an early time. As a child my search for meanings was informed by repeated encounters with the Italian folk tales collected by Italo Calvino (1956), where old witches lived on trees, plants spoke, children were chopped up and yet kept living. The thread of my understanding was being woven. Listening and writing keep to date that sense of weaving by assonance and association, by metaphor, by reasoning through frenzy in listening—scattered items tied together, a nosegay of culled flowers kept together by the thread of my history. And the question is no longer who I am, but *whom* my words are woven into, and how.

As I write, I recall some verses from a favourite song by Arthur Russell called *Home Away From Home*, they seem to prompt me further, they say: *The birth of the moment is never ending, The rest is in the centre*. I think of this writing as the never-ending birth of a moment against the rest in the centre, its cry outstretched beyond its edge. Where is the edge of the tapestry of my I, woven in writing and eroded in listening, reading and recalling? In the 1950 foreword to his ethnographical and autobiographical and truly visionary journey *L'Afrique Fantôme*, Michel Leiris writes: *Truly a human measure, my horizon*. Sixteen years before, he'd closed the book saying: *There's nothing left for me to do ... but dream*. The time of each recorded memory is spanned by and spun around the horizon of now and the edge of dream. In the thread of every record I hear what wasn't there and I make what is gone, actual. An escape out of fixity. In what might be yet another horizon, I end here with another possible beginning:

Chapter One

Grandmother did not go to school, she could not read. She did sing. Out of the cave at the back of the house in the mountains, that herself and my grandfather used as a cellar for bread, meat,

cheese, firewood, I can recall her lullabies.

A few years ago I encountered similar tunes and strident voices in the ethnomusicology section of the archive at Santa Cecilia Music School in Rome: the lullabies of my youth were turned inside out into the dark undertones of funeral lamentations, recorded by ethnographer Ernesto De Martino in the 1950s in Southern Italy. Both De Martino, and Alan Lomax a few years later, wrote of how in those lullabies you hear acute voices, mournful melodies that mirror those of lamentations, as patterns repeated at different points in life. These songs in birth and death do not voice absolute meanings: they are shaped by the time when they emerge, new in every new voicing. As I read along these voices and between their gaps, I begin to hear new disturbances, I respond to their speech even when I'm not quite sure what they say. Like my grandmother, who could not read and sang not because she was quite sure of what certain words meant, but because she had the urge to let her voice arise out of those strange words nonetheless—because either she would resist language, or break it with her song.

8.

Boxes

My archive has been in fragments since I decided to leave Italy six years ago. It resurfaces intermittently when I write. My physical archive—documents, CDs, books, leaflets, source material used for projects, tapes and ephemera—was left at the end of 2008 in the basement of my parents' house, waiting to be shipped back to me in London. Circumstances and lack of space prevented me from organising one major shipping. The shipping has been taking place bit by bit all these years as I arranged, every few months, having a box shipped to me with randomly mixed items inside—at once a reminder of a collection, an erosion and a recombination of my archive and of my histories of sounds, an unpredictable prompt to re-collect.

* * *

In the box I received today I found, on top of the pile, an old VHS tape from the Italian national TV archives, marked *Pasolini / Pound*. On a smaller sticker, I'd written *voicing heritage*. I no longer have a VHS player but I can remember what the tape holds. I recall some verses: *What thou lovest well, remains, the rest is dross. What thou lov'st well shall not be reft from thee. What thou lov'st well is thy true heritage.* I recall these verses as they are read by Pier Paolo Pasolini during an interview he did in 1967 with Ezra Pound. I recall Pasolini as he reads aloud, in an assertive voice broken by gasps of hesitation, Pound's verses from *Canto 81*, embodying one of those crucial encounters between writers when the voice of one inhabits the words of the other, and gives them another sense from within their reading. Pasolini was concerned about injecting a *desperate vitality* into the heritage and

the voices of a vanishing culture: the Italian peasant culture, its dialects, idiolects and inflections, usually mistaken for *the voices of trees and of yard animals, at the most as the voices of a separate and archaic culture.* He attempted to work with his heritage as if it were a driving force rather than an encumbrance. His heritage didn't radiate from any ideas of permanence: it chronicled the metamorphoses of an attachment. *What thou lovest well, remains... What thou lov'st well is thy true heritage.*

And what shall I do with my heritage of listening? How shall I archive this heritage when I write? Does it make sense to want to preserve such heritage or is it better instead, like Pasolini would say, to claim tradition back from the monopoly of traditionalists: to work with it as a dynamic force?

Of late, everything when I write after listening has been taking on the form of a recollection from a past, and yet it is not nostalgic: it is pervaded by the feeling of how the supposedly linear life of each listening moment is transformed, because of its end, into an overarching curve. A curve that curls words and rhythms on itself, and prompts to hear. *What thou lovest well, remains*, I repeat to myself. *What thou lov'st well is thy heritage.*

In the Italian translation of Pound's *Canto*, *heritage* rhymes with *vanity*: *eredità, vanità.* Heritage and Vanitas. The more I think of heritage, collections, archives, the more I am reminded of a vanishing, a silencing. Most of my archive is silenced: pages and pages written in Italian, a language few will understand. Yet it resonates every other time I write. And if my heritage is supposed to inform my identity, then I think of how in 16th-century English, the word *identity* was spelled *idemptitie.* Any assumed identity of sound, defined through its archives, contains an empty—an emptiness which is also a resonating space for the echoes of my silenced words.

In the box I find an old Penguin Books edition of *Wide Sargasso Sea* (1966) by Jean Rhys, and inside it, on page 25, a postcard of a painting from the Munch Museum in Oslo. On the back of the postcard I'd scribbled: *Heritage, or: the sorrow that my heart feels for.*

The painting by Munch is entitled *The Heritage*: it presents a conventional frontal structure—mother holding child in the tradition of the Renaissance Madonnas—and yet, as often is the case with Munch, something is out of control. The child is a milky white foetal figure in the middle of the composition, milky figure surrounded by a white elliptical shape. The whiteness is glowing. And yet as I get closer to the image, I notice the white central oval is soiled all over by little red dots: I move my eyes toward the mother and notice that her mouth is covered by a handkerchief. She has been coughing blood, the drops on the white child are both suffocation and relief.

This painting is entitled *Heritage*. What is the heritage of sound? Is it white, pure and sanitised, or is it infected, splattered with the bloody dots of many legacies? Isn't the heritage of sound splattered with the bloody dots of any attempt at coughing some words out of it, a sickly half-formed lullaby to hush it into silence? On page 25 of Jean Rhys' book, I encounter a verse from a song: *The sorrow that my heart feels for...* I couldn't hear the end, but I heard it later, before I slept, *The sorrow that my heart feels for.* The moment I begin to write, sound is no longer sound. It is infected by the small, unsettling dots of another presence, and this presence needs consideration because it is not born out of sound but affects it. Like the final scream in *Wide Sargasso Sea*, one hundred and twenty-odd pages accumulating in the premonition of a howl intense and secret, cut off and relieved by the final, far-away scream of the madwoman in the attic, one hundred and twenty-odd pages crashing onto the final question, *Why did I scream?*, to write sound is to write a premonition and a presence, and to keep asking that question at the end: *Why did I write?*

I once knew somebody with a huge record collection, who would put little marks on the back of his record sleeves and CD covers, to point out the songs and tracks he believed were worth saving for future listening. *So I will know exactly where to go next time I listen to each record*, he maintained. No record was spared the treatment: he would single out specific elected timeframes, even in apparently monolithic works. Each mark in his archive, a tentative shortcut to memory: a tentative way of hanging on to an illusion of permanence. It reminded me of some classmates at school who would underline the allegedly important bits in their books, slightly afraid of what might be left, afraid of what was not prone to synopsis. Always this looking for an indelible mark, an inventory of permanence. But what do we mark, or keep, in and after listening? Where does the ephemeral mutate into a presence? Somewhere at the margins I look for shadows, closer to the shape of my hearing. I think of all the records in these boxes, my archives of sound. Archives seem to protract an illusion of possessing history and knowledge. Moreover, archives are often mentioned in relation to the verb *access*—archive accession number, accession form—in turn implying a boundary, a border: to access, a step into and out of. And how about what is not archived? What is silenced, and cannot be accessed? Could I think of my words as silenced chronicles, set against their shadows? Could I think of these silenced chronicles as the journal of an apparition, borrowing the title of a text published by Robert Desnos in a double issue of *La révolution surréaliste*, October 1927? It describes the mysterious appearance of a woman, marked by three asterisks, who constantly slips away. Meanwhile, words and characters on the pages rehearse an absence.

In the box I find a photocopy of a poem by Emily Dickinson, *I Felt a Funeral in My Brain*, that I once used to outline the paragraph beginnings and rhythmic patterns of a text I wrote for an Italian artist. That poem—a descent into obsession, conveyed by sonorous signs and repetitions—also reflected my state of mind in 2008, when I found myself at a standstill, I stopped writing, and I took some distance from the world of *sound art*. I could no longer think of sound as a generic entity, detached and pure, without feeling confined. Like the barren scenario in Dickinson's poem, I was solitary in a world where talks of sound, sound art, art and sound seemed more and more preoccupied with their own form, exclusive and excluding, as they outlined sound art as a credo. Many museum directors and curators would only welcome projects if they featured at least one of the superstars of sound art. At conferences, people would only appear to acknowledge references to certain artists-authors-authorities. Those references were like the underlined parts in the books at school, like the marks behind my friend's CDs: they represented the illusion of one, canonical history.

Many seemed impermeable to the rest, to less accessible works, to what could not be certain, consolidated, archived according to the canons of sound art. Weighted with generalisations, the discourse around sound art was slowly morphing into a dictator of a certain type of aesthetic experience only accessible through certain doors and through a certain way of presenting it and writing it, where the only possible space had to be public, where the only references had to be funnelled in the narrow corridors of Nauman. To my ears and words those doors were closed, they prevented me from accessing any experience of listening, and writing afterward. The term *sound* became a way of adding an aura of mystique, which I found hard to relate to. Press-release recurring trope: *This is a new project in which the artist uses... SOUND*. But *what* sound? Please don't write that the artist worked with *sound* as a magic key into an exclusive under-

standing. Tell me, *what* sound, *how* sound, *where* sound. The sound of a tone generator? The heavily distorted sound of sheets of paper being crumpled? The sound of the recording of the last surviving Kuau'i O'o A'a bird in the Hawaii? The sound of muffled voices emerging from an old reel-to-reel machine? The sound of work songs? The sound of old lamentation rituals recorded by ethnographer Ernesto De Martino in Southern Italy in the 1950s? I could not hear any of those sounds, in the words around *sound*, any more.

I distrust any talk of sound art when it operates like certain religions do: like a set of rules in between you and some fixed divine notion, using a cryptic jargon enclosed and controlled, a language which does not voice much engagement with listening. At the time I had nightmares of the Church of Sound Art as it wrote its holy scriptures of *tactics of augmented aurality, auditory paradigm, the problematisation of strategies of listening.* Strategies? Tactics? Nobody ever told me that to listen you had to be in politics, or at war, or both.

What had begun as sonic pleasure became my sonic doom. I stopped writing. I had to find another way for my words through sounds.

To write sounds does not mean to document them, to preserve them as intact entities, but to contribute to their decay, at times to be pervaded by a sense for something that may have not been: to write a history of dissolving and dying, a tanatography. Every word is a *rubato*, stolen from each sound as it expires—stealing a piece of time. To write sound is perhaps to build up an archive of approximations to nothing. Or maybe these word-archives are only cataloguing themselves, as sounds... a trick? Listen and then write, and you'll know you're being framed by this sense of vanishing and there is no big explanatory sign at the end. Stop prostrating to the moral of making sense, to the frenzy of documentation. To write after listening is to forget the sense and the scene. Words mess up any univocal comprehension, like a sound produced by the simultaneity of two vibrations that do not coincide. They pour out the hopelessness of sense and of subject, in the plurivocality of each line as I speak it. As the Italian performer Carmelo Bene once said, words as they're read out loud are not symbolic: they are diabolic.

In the box I find a copy of *The Blue Rider* almanac published in 1912. I read *The Relationship with Text* by Arnold Schönberg, an essay that supports intuition in listening, beyond instructions. In any point you pin music, he says, it will bleed. However you might want to dissect it, you will see a blood flow. At the time Schönberg was writing against programme music, intended as a faithful correspondence between a prescriptive text and subsequent sounds. I'd like to turn the issue upside down and think of the relationship between sound *before*, and the words that may or may not come *after*.

So what happens when I write *after* listening, even more so when I write in a foreign language that sometimes leaves me grasping for words? Can I shift the trite question I am often asked, *Do you dream in English or in Italian?* into *Do you listen in English or in Italian?* And then, write. The fact that I am more inclined to write of my listening experiences in English—a language that bears more opacity to my ears, not being my mother tongue—tempts me to make the opacity between sounds and words even more obvious: any correspondence between them is illusory. Words exist in the porous space of my listening in a foreign language, and struggle to be anchored to anything definitive: because the only anchors belong to another language and to another listening which are gradually drifting away, becoming ambiguous. Between voicing and silencing, to which extent can my words channel the inner soundings of other references, of other archives that fewer and fewer people know?

I leave aside the old remark that it's impossible to write about sound, and think instead of writing away from sound. I stop considering writing as a by-product of listening, constantly frustrated by not being sound. As a document of sound, writing fails. Writing after listening seems closer to fabulation: a creative act, grounded on its own devices and artifices, that implies a number of formal choices. It supports the ephemeral in listening, it is not tied to a permanent origin: out of the complexity of each

encounter with sounds, words voice the oscillations of memory. They construct and open up each experience of listening rather than being subordinated to it: they create another space for inhabiting sounds. They gradually *shape my recollections of each listening moment,* until they feel so close because they're closer to my understanding of them now, not to the reassurance of their past. Like music for Schönberg, if you pin words they will bleed, too.

At the borders of the I and of the archive, on each individual experience of listening I stitch words together and let the resulting off-centred construction clash with any ideas of permanence. I realise that a distinctive pace holds my words, with recurring rhythms and turns of phrase. At first I don't understand it, yet I keep listening, I'm open to the shape my words take on as they lay over sounds with their own pace. It is the pace of my thinking-breathing, that inhabits me although I cannot tell how it functions; it is the space where my archive really comes back to life, the space where I stitch all those fragmented records and traces together, the references that have been layered in my listening and understanding through the years, the singular experience in every edit, in every voicing, absorbed and shadowed by what happens around my words and in spite of them. Then, I am tempted even more to claim for the precariousness of any writing after listening. Because if I believed that these words could stand forever on their own, and keep any experiences of sounds still within, I would be beaten: they are eroded by what they do not say. Like sounds, words won't outlast me.

Boxes everywhere, my archive of sounds. Are these boxes all that's left of a life? In another of my notebooks I find a quote by Luc Ferrari. It says: ...*a different manner to use the autobiography, like media, that is, labyrinth kind of transporting information.* The quote is from his notes to a piece called *Now, or Probably my Daily Life is There, in the Confusion of the Places and the Moments* (1981/2). Projects of sound art, events, reviews, in the confusion of the places and the moments... Over the years since I packed and moved, they keep returning unevenly, as harmonic frequencies of myself. This archive is not a keepsake: torn between two countries and two languages or more, it shakes any sense of safety and yet it keeps prompting me. This archive is like a sibylline presence. It won't answer any of my questions, so I have to reinvent myself in a silent state of hearing and find the answers in everything that the records in the archive do not keep and do not tell me.

To record comes from Latin: *recordor*. 'Re' is 'again', 'cor' is 'heart, soul, mind'. To record and to recollect: back to mind, back to heart. *What thou lov'st well is thy heritage. Recordare* is also a section in the Requiem Mass. So, to record is partly a mourning, partly a repetition that brings back to heart, mind, soul. Any permanence, eroded in its mourning. To record in words is not about keeping, but about sounding a vanishing. Alive, and against any evidence.

At the bottom of the box, I find a mix-tape of old Italian pop songs. Titles and verses seem to prompt me: *Words Words Words, I No Longer Know Anything, This Desert Full of Voices*. Syrupy or trashy pop music, by starlets and songwriters who either could not sing, and sang nonetheless, or who exaggerated their melodic prowess. To some ears, these songs might sound tasteless and yet what I seek, as I rummage through my archives of listening, is: less taste for sound.

* * *

I close the box. I see a writer, sitting on the steps of a museum where a sound art show is kept, sitting outside, listening to the leaves as they fall and to the siren from an ambulance darting on the street, and her words after the show will be quivering in the rustling of those leaves, shaken by the uneven rhythm of the siren: outside, and outside.

The words will be soaked in all the sounds she did not write.

9.

Leftovers:
From the Notebooks on Writing Sound

12 March 2012

Words of sound cannot be disinfected, pure, sanitised. Open to a thinking-writing that digs and moves, no longer interested in accomplished forms, I want words to follow the untidy movements of listening, to be mud and magma, from time to time in exhilaration or stillness, in quietude or uproar.

* * *

In response to an invitation to contribute to *Beyond the Object*

2 April 2014

Which object, how? While I felt another presence in the space of my thinkingwriting, to think the object became fatigued. The object, I could only conceive of in the nowheres of fiction. Or in a habit of the void. In the world of ideas where there was no cry nor sigh, but in life: but in life for some time all was pervading like the weary cries of bats who flapped here and there: on the corners and edges of the house and of the things in the house, wet with inexpressible desires of emptiness. If in my giant claim to hold and write less than others I got lost, it was not because of the void that flourished outside my window but for the fullness of reading that admitted no obstacles. If I raised the barriers of void again. If in the precarious empty house made of traps, hatches and oblique movements: permissions to the void: I became acquainted with hours that were mixtures of time and of rearranging objects, when every sigh over every object contained the time of yet another existence.

I don't understand and continue writing my book in this book and close to more books: my writing marginated, edged, boundaried in them. Thinking beyond the object: does it voice the need to be cave, void, resounding? There is no object or sense but a sensuous being drawn from quasi-objects in reading. The truth of the object is something I need to lay claim to: the truth of the object needs to be cursed, a curse sought to burn the usual language, and to fuel the burning tip of thoughts that spring rich with interdicted ideas, too often silenced in a rush toward clearer horizons where the illusion of a solid certainty numbs you — you, reading, thinking, I am a crumb that won't melt in water. I am one who regrets being held hostage by the cursed lump in her throat, but — it is not solid, it is a thing dreamt from something living, while with starched hands you hold no object, you hold another emptiness, *like a cinder, black and crumbling to the touch.*

* * *

The resulting sound was a muddy epos, all groans and fractures, guttural at its outset, it would then end up being channelled into a broken rhythm, monosyllabic, bone-tone bone-tonal. An uneven matrix of high-pitched interjections urged the drama, with wailings, murky assortments of Celtic vowels and gargarised cachinnations. Trying to supply for the disappearance of linguistic substance. Out of suspended intervals beyond any clause, a handful of notes came out of the silences, nearly abstracted out of space, sustained and profound, like the knowledge of grief: immanent to earth. And out of the depths of a lost country, my hidden sighs were released, hidden sighs once erased. Then she grinned, she spoke:

With you I have searched for the immense and perfect disharmony, but these bass sounds resound even if you don't excite them, even if you don't rearrange the avalanches, the screams, the tiny creases in

that safe shawl of comfort. Between you and I a translucent glimmer flows, it moulds every past experience and shapes it into a mobile unspoken phrasing. Dispel if you wish, the mountains of a dispelled life. Dispel if you wish, but every other yesterday I could never quite encounter you, and now I dare not dispel myself. Dispel if you wish, this feeble life embroiled, dispel my embroiling. Let ardour become conversation, let spring sweep away withdrawal, let summer burn violent and incautious, be with my keyboarded hands, key-locked hands, hands locked. Outside let the hurricane sweep. Leave the safe shawl of comfort against this morning's iced sun, leave it, loosen, and let me hear the encounter in a flurry of excited strings.

* * *

Mecropolis

This coming to a foreign place: to be able to say its name correctly, to be at home. Around are plants whose name I do not know, and this broken weather, that I might be listening to with ardent quiet, and void between my listening and my words. See, nothing here is literal. Maybe a snap of thought uncovered something elsewhere: a note. This opacity of words of sounds begins to look like an uneasy special place. Deprived of proper words and of horizon I have no voice here, nor song, but a tongue tied to a thick rope of hemp right in my throat. It chokes me inside the barrel of my every London morning, in sawdust days of tea and tar.

Keep the words worn out, listless by this choking, keep the ruptured breathing.

* * *

11 June 2013

At Café Oto tonight Akio Suzuki hammers nails into a wood plank, in a resolute honing of sounds, a devoted action of closeness. For every nail in the wood, a pierce in the ears and a

sharpened insight, inhear. The inner sides of Suzuki's hammering thump are darker than their outer part and softer at the edges than the centre. Hammering in this room, softer at the edges than the centre. Days hammered upon, *think of what you are doing.* Against these odds you can only hold a feather and hammer nails of resolution and persistence, softer at the edges. These words and echoes and thumps and wails could flip over to the unheard, to the not-paid-attention-to. They could be here or could not. Step into, or out. In, you hear a hammering resolution, out, you see a feather. Be a feather with the same precision as that hammering, spend time with every filament, make yourself more transparent and nearly invisible but present. In complicity under and over public lives. Hammering sounds, softer at the edge than the centre. Reverberations of stones and voice. *Analapos* is the name of Suzuki's echo instrument. *Analapos* string reverb listen exhaust. From hammer to feather to breath. *Analapos*, in a sounding understanding where *ala* is wing and *posa* is lay, *n-n-n* and here we are, caught between flight and stay. Us, cripples who once flew, who spend all our life chasing a hidden goal. Think of those who, in private spaces and houses or psychiatric institutes try piling up cards or hammer other nails or conjure up unlikely enterprises as private revolutions, often patronised because they either care too much or their goal appears futile and light, like a feather. Think, few things can match these, the study and dedication of those who devote their minds and bodies to reaching the impossible feather-like fulfilment in devoted actions of closeness. These people have friends and lovers and relatives who keep reawakening them to daily matter-of-fact. *Think of what you are doing:* a feather. Those who hammer and are like feathers don't have any value. Barred from history they hold no fellow-ships or honours, yet also because of them, being alive matters.

It is stifling hot in the room, somebody opens the door, a siren enters and wails. Recollect your Oto sirens. The siren that cut a slit into the muddy grumbling bass slabs of Ambarchi/Csihar/

O'Malley. The siren that, like a welcome sign of outsideness or a break into boredom, opened the space of listening outside of a *panel discussion*. Sliding playfully along that siren's uneven coils you then thought: *Take six panels (wooden), hammer all the discussing people inside and rejoice in the muffled sounds of their smothering*. The siren that haloed around the sharp geometric arrangements of Asmus Tietchens until you no longer knew if it was imagined or bounced off the crystalline formation of frequencies so beautiful and enclosed. The siren that you'd hoped for as a distraction, because the music sounded no longer enough and you were striving for a prompt to divert into contemplating an illegitimate echo-logy of thoughts. Remember then, the siren that broke the newly-met silence and met you at 6am walking on Karl-Marx-Allee in Berlin ten years ago, after you'd seen the dawn break from the huge windows at the Panorama Bar in Berghain, above bodies and techno bedazzlement and movement and thick air and euphoric thoughts of abandon.

I call you call you Siren, furtive siren. In our Oto date tonight, hearing watching, the air in the room is dense and full of echoes, whistles, whispers, and you and I are in here in pandemonic thrill gazing at the sudden swollen portion of space that melts the next breath into these words, the light persistent buzz flipping up the undersides of breaths, bruises behind, the trembling. To you these nails; to wait, this hammering.

Now it is 11.05pm and a thin mist has descended on the streets. As we walk, shop signs and car lights draw vaporous trails in the triple dark. We enter the Dalston overground station fleeing like feathers and dizzy with the echoes of hammering.

* * *

5 April 2014
What do we do in front of an archive, the stern scholarly voice asks. The scholarly voice should be less stern and less concerned

with itself. Kinships here need to surface, histories and accidents against the strong linear pull of our finitude. In front of archives we are tormented because we come to terms, with no easy escape, with the pull of our finitude.

Hence the objects: habits for our delusions of permanence. But archives; archives are not still and safe but corruptible and so are we and as such we meet brimming with histories, unsafe and corruptible.

* * *

13 April 2014

These Sunday afternoons become blanched with habit, these afternoons rise. This Sunday is the day of Leiris, Lispector and listen. I find myself foreign in a new language and foreign in my old, among sounds constructed and undone. Meanwhile reading has become tied to a habit of the void. Because of the ceaseless demands of productivity, I curl into a silent companionship with words. A critical retreat? A nest of silence. But it is no time for irony or distance, it is time to recollect these eroded words and no longer polish them, only rearrange them and let the patina of time show through them.

These days when the word *research* is worryingly loaded with outcomes, selling points, annexed by violent, forceful words such as impact, production—these days, fly off toward less negotiable transactions. Sunday, day of echoes for Lispector, of partial echoes in memory for Leiris. Isn't Sunday the ultimate day of resound: resounday? Converse with your absent ones; hear a thread running murmuring beneath all this; write in response to an unresolved urge to address the most fleeting yet persistent sense of a dark unspoken tension and a nearly occult texture of togetherness that will tie sounds and words inside a book together.

* * *

Revisiting old habits, slowly reading the notebook backwards in the hope of heading toward a beginning, until she gets stuck on the same page for days, then writes: *A sense of what I do lies at the margins of a core that is not. While taking a detour from what I assumed was writing, I encountered writing.*

* * *

What haunts these pages from the aural Wunderkammern of memory?

* * *

Writing Sound: not invention as creation anew but, after *invenio* in Latin: to come across, to encounter.

Writing Sound: the evidence is lost, or assumed, or no longer there, or was never quite there as evidence, but as transience.

* * *

At the Sound Art Conference

It seemed I'd stepped from the rainy morning walk into a room of frozen thought. The room was full of people between their twenties and their seventies and yet it seemed most of them had agreed to set their understanding on an average age of middle. Middle thinking, I mean. The safety of the shared, mental age of middle. Wrapped in self-aggrandising frameworks, the curators sheltered their thoughts behind the flat screens of *presenting* (as in: *I'm not making any statements here, I have nothing to question, I'm just presenting these slides to you*). Artists tiredly repeated conformed formulas to forcefully comb their pedigreed works into more flatness—*I am a* sound *artist—sound* thundering in the

* * *

I watch Federico Fellini's *Nights of Cabiria* (1957) and I'm trans-
fixed. I'd watched this film and *La strada* (1954) on TV when I was
about four years old, and never again since. To date, these two
films are my earliest memories of sadness, from an age when I
could not have possibly ever experienced that type of sadness.
Except through those films. I was always afraid of going back to
them. So here we are, that sadness and I, thirty-odd years later. I
find: a film of unstable balance between a profound sense of drift
and emptiness (the bleak suburban Roman landscape, caves,
open spaces, the main character truly lonely in every sense, no
respite ever) and a lightness of touch, graceful interferences of
unexpected gestures that place what is implausible in what is
stark real. Rituals and representations exceed a self that is inher-
ently void. At one point Cabiria joins a pilgrimage to the
Sanctuary of Divine Love and asks for grace. One of the women
in the crowd shouts at the top of her voice, speaking to the Virgin
Mary: *I am REALLY asking you. I am REALLY asking you.* As if
screaming created the space where belief is validated. Cabiria
cannot quite scream and she barely sings, she is hushed and
overwhelmed by the chanting and the demonstrations, the
gestures, yet she is the only one who believes—maybe because
she's speaking to herself, not to any divine presence. In the next
scene they all sit on a lawn having a picnic, life goes on
untouched by the empty yet repeated ritual, except for Cabiria,
who is deeply affected by the fact that, after the pilgrimage, *nun
semo cambiate* (in Roman dialect, *we haven't changed*). In the end,
the space of utter truth is revealed to be the space of utter
deception; unlike later films by Fellini, here truth and deception
exist in osmosis, they do not outnumber each other by means of
cartoonish exaggerations. The edge is softer and I am more easily
driven in the film, not as a spectator but enmeshed, affected.

(Then I think of another heart-breaking scene of staged faith,

make-believe and loss of belief, in Lars von Trier's *Breaking the Waves* (1996), when Bess goes to church for the last time and can no longer sustain the double-voiced dialogue with God that she's been staging up to that moment, deceiving or asserting her own self by speaking in two voices.)

* * *

The face of a woman resembling Norma Waterson, placid and ancient, greets me in the late afternoon train. It is summer and golden sunlight touches one of the woman's cheeks, that like a prism seems to reflect its luminous texture onto the entire carriage. It all darkens as I hear the unexpected accent of another woman talking on the telephone, beastly mixture of English bastardised with the harshest vowels of Southern Italian speech, those u's and e's, edgy and prickly like the thorny undergrowth in the Southern mountains' woods in their long cold winters. Against an approximation of English vowels, they sound even sharper and sourer. Until at once, out of this leaden vocal wedge of rocky vowels and highly-strung speech jolts, I encounter again luminosity: the mellow sound of *iatevénne*, heard years after the last time I'd heard it, probably from my grandfather or most likely in the whining intro of Almamegretta's Mediterranean dub *Gramigna*—I never made much of that song, other than the whining intro and the mellow convoluted moan of singer Raiz swaggering through the song as if in a dream, or as if the voice was to be expelled out of his throat, maybe for the last time ever. Today *iatevénne*, the Neapolitan dialect expression for 'go away', is sweet and disquieting. Here it is again, I hear a familiar disquieting sound on a train travelling South-East, go away, away, the last voice I can recall of an underworld only heard inside, a last voice from home. This voice charms, inside leaden voice, grottoed voice, and in an assonant flip of my listening *iatevénne* sounds its leaden echo in Persephone, I hear Persephone, go

away, Persephone, I encountered you in some pages by Leiris that I read a while ago, and all I can remember is the mineral sound of your noise, the anfractuosity of your voice that I never actually heard but was echoed so strongly in his words.

MOTHER: And when Persephone disappeared into the underworld, her mother was so sad to have lost her that she established it would be spring and blossoming all around when her daughter would reappear on earth, and bleak and barren days when she was underground. That's how the seasons were born: so that Persephone's mother could mark the time of her daughter's return.

DAUGHTER: But what of the time she spent in the under-world?

Silence

* * *

I watch Pedro Almodóvar's *Dark Habits* (1983).

I picture in my mind a satirical scenario that releases me from the anguish of writing this book:

THE DARK HABITS OF THE CHURCH OF SOUND ART and its humiliated redeemers.

Obsessions, manias, hidden passions that arise in enclosure and confinement.

Etc.

* * *

Writing Sound: where? In ellipses of instances of hearing.

* * *

Make a compilation of the words before songs sometimes heard in live recordings—the singer tells a tale, an anecdote, makes a

cheeky remark to the crowd or recalls the first time he or she sang that song. Only keep the words—hilarious, self-deprecatory, melancholy, sanctioning—and not the songs. Think of the absent songs, stuck in words of anticipation and remembrance.

* * *

Possible Titles

F.M.R.L.
An inside narrative, with some sound-pieces.
Sonic Doom.
Mondo Sound.

* * *

He said: I say! Are you working?
I replied: I am writing Marshlands.
And what is Marshlands?
A book.
Would I like it?
No.
Too clever?
Too boring.
Why write it, then?
If I didn't, who would?
André Gide, *Marshlands* (1985)

* * *

On 16 June 2007 I walked with artist Paolo Inverni, for an hour, inside an underground cave at Rio Martino in Piemonte, North-West of Italy. The cave stretches into the core of a mountain in the Alps, along two levels of underground tunnels, for about two miles, in total darkness. The local council lists the following

characteristics of the cave, to be considered by anybody who might want to walk in it: humidity 100%, temperature 5.5°C, an underground river, walkways without handrails on both sides, relatively low ceilings in some places, jagged outcrops at head-level on the sides of the walls.

The underground river can be a route to follow or a hindrance. In the points where the water level is low, the riverbed is a guiding path. When the water does not allow you to walk in the riverbed, you are forced to clamber along slippery edges on the sides.

Inside the cave, darkness looms and one false step could be fatal. The sense of danger is not only physical. Only once did I stop walking and was overwhelmed, although I'm unsure as to why: was it the darkness that the lights on our helmets barely disrupted, the awareness of being so out of reach, the lack of living organisms around, the uncanny reverberations of our voices, the oppression that engulfed me as soon as I entered. To quote Jules Verne in *Journey to the Centre of the Earth*: I felt lost. *As long as you stay close to the walls you're safe*, Paolo said. But the walls are slippery. I could only walk, and keep walking. Long stretches of silence between my friend and I were only interrupted by trivial communications: stories from our childhood mostly, episodes of strange play and remoteness. It's odd, I thought: to try and fill this emptiness, we speak of long-gone times.

At the end of the cave, after walking for an hour between the river and the walls of rock, a sudden change: a sudden blast of cold air, countless drops of chilled water against my face, and a roar amplified out of proportion. This is what we came here for: an underground waterfall, one of the highest in Europe, cascading from a height of fifty-five meters. In the darkness of the cave, I could not see the waterfall: I could feel it, and hear it.

We could barely talk. The recordings of the empty tunnels we'd been doing up to that point, had to be stopped. And there

was no way to do an audio recording of the experience of the waterfall after the hour-long walk underground, we'd have come up with shapeless noise anyway. Better to listen. And think of another type of recording, in the words that would follow the waterfall.

Then we had to get out of the cave, another hour-long walk through a tunnel of black and silence faintly measured by tiny water drops. Only in the walk back did the afterlife of the waterfall, and perhaps its sense for us, begin to form: not just because we had been there but because we had walked away from it, with no actual recordings to bring back, and yet still hearing it reverberating in the tunnels of our recollections. We didn't have an audio file with us, but that didn't mean the experience would vanish.

The first thing I noticed once I walked out, after adjusting to the blinding light of the mid-afternoon, was a patch of lichens. I thought of Camillo Sbarbaro, an Italian poet who wrote broken verses of small utterances, at the beginning of the 20th century. He also collected lichens. Often he would write of his words becoming mineral, and himself too. At the end of the thirties he wrote, in a collection of fragments called *Wood Shavings*:

What remained inside me of what I'd felt, was what is left of a whispering; something incredible, which I seemed to 'hear through'; the wonder it gave me dwells on. And if that place is vague to the memory, as the place pointed at by the Sybil's reply, then the fear of not capturing the place sharpened my yearning.

I want to dwell in this state of hearing through, write of caves and voice Sybil's words, to dwell in these transitions between being in a place and the premonition of its absence.

10.

Lakes, Sounds, Sculpture, Really

One of the works of sound art that years ago sharpened my awareness of the sonic realm beyond the audible, is the *Concert for a Frozen Lake* (1982) by Rolf Julius. At the time, in the early 2000s, I was struggling with the demands to write long articles for a music magazine in Italy, and in this specific instance the struggle was caused by having experienced Julius' work only through a series of CDs—bought in one of many highly anticipated visits to the Gelbe Musik shop in Berlin—through the *Small Music (Grau)* monograph published in 1995 by Kehrer Verlag, and through a low-quality VHS copy of a video, documenting an installation at the Hamburger Bahnhof. In other words: I'd never actually experienced a work by Julius on site. It was difficult to try and put all of those representations together, to somehow elicit, evoke, make-believe the experience of a place through sound—which I felt was the core of Julius' work and at the same time the missing element in my knowledge of it. I had to find another way into those sounds and this way came through reading. I had to find a site for those sounds, and this turned out to be the actual site of my imagined listening, the historical site of my presence.

Up to that moment the idea of sound art for me—it will never be but an idea—had been an uneven, half-guessed anticipation, sonic fragments and impressions of the mind patched together by a thin yet persistent thread: I could hear my idea of sound art in the disturbances heard in the records released by Selektion; in an email correspondence with Steve Roden, not discussing sound but sounding thoughts and books; in murmurs of digital detritus in the early works of Carsten Nicolai and Ryoji Ikeda; in spurious interferences from the lunatic fringe of Loren Chasse,

Thuja, id.battery; in the conceptual excursions of Elgaland-Vargaland; in buzzes, modulations, and emissions of light and sounds from the people at Sähkö in Finland; in still evocations of Akio Suzuki's performances. All of these were relayed unto me by means of records, reports of room-shaking frequencies, other people's memories of unrecordable sounds, their accounts of under-documented activities in urban spaces: news from elsewhere. Something was there, elsewhere, and I found it hard to grasp although I responded to those calls. Trips to exhibitions such as *Sonic Boom* (2000) in London and *Frequenzen[Hz]* (2002) in Frankfurt made my thoughts even more complex, puzzling, and alluring, as I became increasingly engrossed in that sense of a half-guessed and barely-there something, never to be completed, but to be heard and remembered. Maybe it could only really happen in remembrance, reconstructed from time to time. I suspect it attracted me because of what it was not. It was not the music revered by my journalist-collectors-colleagues at the time—to me access denied, because I'd never been in a band so I couldn't *really* understand what music was, and write about it: really—it was not actually just there to be collected as a record; it opened up to spaces, bodies and brains; most of all, it did not require discographies and previous knowledge, to be experienced. The core was not the issue: the borders were.

Things began to connect when I read of Julius' *Berlin Concert Series*, to the point that my understanding of *Concert for a Frozen Lake* will always coincide with the first time I experienced a work of sound art, even if I was not there to witness it. The words he wrote on the *Concert* carried the experience of the work for me: not as a static, permanent, still piece, but as a prompt to listen and think, as the motor of a metamorphosis, as a current, a whisper across time: *I hope that the lake itself turns into music*, he wrote. I asked him specifically about that statement via email, could he recall what happened on that day, and he replied: *The sounds became part of the lake, they became somehow icy... What I liked*

was, the sound of my music was changed by the situation, the sounds became wet and icy. What did he mean? How could sounds become icy? Could synaesthesia reach out to me, not only function between mediums, but between different formats, times and places? Could my projected listening be another medium to synesthesise into understanding? Not a word was spent by Julius on the sounds of those sounds: he seemed to be more concerned with how an impression of sounds in words might join place and people together, in unlikely contraptions of thoughts and senses. I sensed in his words a hint of reality, even if it was a reality brought about by a very special kind of presence, beyond what is tangible, real, justifiable: not in sameness and in univocal positions, but in change, in guessing, in diagonal states of thinking-listening. Marginated into my own space, I accessed the space of the frozen lake through my projected listening, while Julius' words came to me as a vivid call to make connections, the more unlikely the better, or, as Robert Duncan wrote, to detect and nurture *kinships across time.* Conversations with lost voices. Inner dialogues with who is not there but you can address in thinking. To absorb the environment and inhabit it with flickers of presence. To merge likely and less likely sounds, until boundaries are blurred. This was more about change and transience, than individual objects to keep still and perfect. This was sound art to me.

A few months later I visited Julius in Berlin, I shared my mediated yet so real experience of that work. He smiled, and said: *It happened on the surfaces. I called it a concert, it was a sculpture.*

* * *

Sculpture is where the interchange between hearing and seeing happens: on surfaces, like the ones of Julius' loudspeakers or, like the surface of the lake and of memory. Surface is the form of

the contact between different mediums, a dimension that can in turn generate new forms. It has claims to a certain immediacy, a way into presence. Here, it says: not there.

Summer 2013. I am at *Sculpture 2*, organised by David Toop and Rie Nakajima in an outdoors location in Dalston, London. At the beginning of the evening Rie and David sit, David and a guitar, Rie and her battery-operated devices, amongst rubble and uneven ground, part construction site, part melancholy wasteland of the type you might encounter if you imagined an urban laconic version of a late Tarkovsky film. Sounds are not amplified, they are barely audible. The more I look at them—at Rie, at David, at the sounds—the more they seem to gravitate toward the missing corners, or bury themselves lower and lower in the ground, or diffuse into the city noises around, as the twilight is absorbed by the pewter sky and dusky fabric of the buildings. I see them descend, I hear them dissolve. Here is an arrangement of disappearances, a silent pact, I think it is also a quiet prompt to become part of a constellation of sounding phenomena, focused, assured, and yet not loud; to subtract rather than to state, to become and be: dusk and corner, dust and horizon.

They seem to point at the fact that sometimes it's really not important to single out finitude or accomplishments in sounds but rather, sounds can act at switches, point at borders and trespass mediums, toward what we could hear even if it's not defined. Or maybe they embody the making and the collapse of memory. I am attracted to this setup and to David and Rie's choice, not only because it has no claims on any representation of sounds, but also because it eschews any notion of presentation as display. I sense a deliberate form of erasure, of stepping into that elsewhere of sound that first attracted me many years ago— prompting these sounds, their performers and ourselves, to become corner and to become dust. This is not about what you can do, skills; not about how you can represent what you can do.

This is about what you choose to be, every day and every time you experience sounds and expire them in life—about how you connect a string and a shade, dust and dusk, the splinter of a memory refracted on today. At the end I know I have encountered once again, unexpectedly, in a summer evening in the middle of noisy Dalston, the space of my concert for a frozen lake. It has come to meet me in disguise, a concert for a frozen lake in an urban yard in the summer and in Dalston, not Berlin, and in the evening. It has the glow of then and the presence of now, and between then and now I was here.

11.

Inner Voices

Casting

When I visit the chapel all is quiet. I tune in remote voices, I descend, I am the drive downwards, the basso continuo in the madrigal. The chapel is a network of references around the city — not much in space, but across history. I recall some words by Harry Partch:

> *It is one of the purposes of scholarship to discover ethical values and disciplines out of the past, verbally and visually stated, and to preserve them. I care a great deal about contemplating an age or ages that have been discovered through digging and presuming and learning. But I care even more for the divination of an ancient spirit of which I* know *nothing.*

I know nothing of sounds as permanent origins, and yet I'm drawn to listening to them, to reinvent, recall and divine them in words. I tune in inner voices.

* * *

I begin to collect some thoughts around a certain sculpture as a cast, around the sounds prompted by it and by the words around it. The sculpture is entitled *The Inner Voice*. I choose it, not only because of its title but because it exists in repetition and change, and because it echoes the title of another work I will tell you about later, *Inner Voices*, that features among others an enigmatic character who refuses to speak because the world doesn't listen to him anymore, and only communicates with the outside world by exploding bangers and crackers.

The Inner Voice is a sculpture by Auguste Rodin: a body in torsion with no arms, its legs scratched off edgeless, in-between the stillness of matter and centripetal motion. Rainer Maria Rilke wrote of it: *Again and again Rodin returned to this bending inward, to this intense listening to one's own depth. Never was human body assembled to such an extent about its inner self, so bent by its own soul.* Rodin himself said: *My figure represents Meditation. That is why it has neither arms to act, nor legs to walk.* He later used the sculpture to illustrate a poem by Charles Baudelaire entitled *Beauty: As lovely as a dream in stone, as clay eternal and as taciturn.*

The arms might have been mutilated, or maybe they never were. Cast over the years in different materials, *The Inner Voice* is a muted reiteration: it dwells on the changing textures of a form, as an attempt to reconcile its stillness. Rodin took the title of his sculpture from a collection of poems by Victor Hugo, who had said: *The Inner Voice is the echo, certainly confused and feeble, but faithful, of that song that responds in us to the song we hear beside ourselves.*

I cannot quite hear the song of my inner voice but in half-guessed disturbances. To find the sound of that song, its changing tones and their frictions with the shape of their cast, I have taken the inner voice of my reading as a mould and I have cast it in dismembered groups of words, as I learned by heart every week a paragraph from a new text that mentioned sounds, re-wrote it from memory the following week, and interpolated the missing parts with other words heard beside myself—an experiment with layered memory, as it corrodes and actualises my physical and emotional archives while I search for more voices: an echo cast into shape, to fold my enchantment with words round, and back dissolving, and again.

The resulting texts raise many considerations about authenticity, the resonances built within the fabric of language through reading and listening, how to write a writing embroiled. Writing Sound as casting takes shape in the interchange between mould

and material, the empty and the full. The cast is an archive of sounds—not only an actual collection of recordings, but also comprising recollected and incidental memories of listening. The material is made up by the words generated by the archive, by the incidents and interferences that accompany or derange them, by the recurring challenge to elicit sounds' presence in and through words nonetheless, rather than referring to sounds as absent objects.

* * *

First Cast. Recalling *Awakening to the Great Sleep War* (1982) by Gert Jonke.

I talk to you as slow as possible, with pauses between each word, between each syllable, so that you might be able to hear every-thing I say or ask, even when I speak softly, or just think. Your words take the form of a not-quite-describable trembling of the sounds and the light in the air around you: I think I can hear it quietly, I think I do, although *hearing* probably isn't the right word, although each of your sentences seems to be slowly and carefully spelled and then spoken, but *speaking* perhaps isn't a suitable word either, not for this type of conversation, those flickers of light flashing through your thin matter, whispering, nearly invisible blurring of the air that quietly surrounds your figure, that trembling of your head in a manner just barely perceptible: when I listen to you, sculpture, it often seems as if I was hearing you with my eyes.

* * *

Second Cast. Thinking of Baudelaire's *Beauty* (1857).

Today it is time to consider what is left of this face and body; its marks of impermanence. Apparently motionless in its encrypted silences, the inner voice actually attempts to climb up the walls of

its own substance, and curls back in the recurring hesitation of a vocal contortion. I haven't recognised you in this silence, not in your gestures, but in your muffled screams in this urban cave. Some voices in you speak of fleeing, but how about those that ask for lingering, for dwelling? With a chisel, I double them up. With a blade I trim their edges for fear that their sounds, too alluring, would arise in my nights and compromise my sleep. I no longer recall which voice awakened this lament, while all the other sounds played their part and carved my understanding of you, as lovely as a dream in stone, as clay eternal and as taciturn.

* * *

Third Cast. Recalling *Acquainted with Grief* (1963) by Carlo Emilio Gadda.

Alone she walked in the house. Was it all that was left of... a life? Boxes of records from the past, but she knew, that July wouldn't return. And what would those recorded sounds bring, to the resounding howls of that July, if not the heightened sense of today corroding them from the edges? Outside, the day with heavy clouds was as grey and heavy as another day, when the inner chattering swarmed upon her and she would ask, why now, why now. The line of a memory had cut a slit into that July. And she knew it would never return.

The day after, the bronze toll of midday out of the bell tower, above the flutter of leaves, separated her from that memory. She walked toward the cemetery gate; through the half-rotten wooden bars that attested a senseless private property she heard, like many other times, the clarity of summer. The endless rustle of leaves seemed to belong to the same light. To the right, the mountains would rise green and dark, and on the other side, after the idleness of a field, hills and more hills into the light, and more. Her eyes wanted to chase a new fable, tenuous across far-away scenarios and the tricks of perspectives. Names crowded

up, forgotten causes to a weak effect, erased like her very surname on the old tombstones: a non-visible summary of long-gone reasons.

* * *

I've been tempted by broken utterance and the need to say is always there, in spite of dissolution and rarefaction, a sonorous nothing, a stuttering reverb. What are all these fragments attached onto? Each thought, each recurring cluster of words was not created anew but cast from words that were before, recalled from residues and archival layers. I can only transpose and rearrange as I'm cut through by voices I don't want to explain, but transform and shape as they expire: in proximity rather than in understanding.

As I write, I recall some verses from a favourite song by Arthur Russell, *Home Away From Home*. They seem to prompt me further: *The birth of the moment is never ending, The rest is in the centre*. Now I know why *The Inner Voice* has no hands and why my inner voice cannot find its original voice and still, it writes sound. It's the never-ending birth of a moment against the rest in the missing centre, its cry outstretched beyond the borders of its body to be cast over and over again, an echo of echoes, headed toward transformation and change rather than tracing origin and keeping permanence. And the question is not who I am, but *whom* my selves and my words are cast onto, and how.

* * *

Le voci di dentro

Le voci di dentro (*Inner Voices*) is a play written in 1948 by Neapolitan playwright Eduardo De Filippo, legend has it, in only two days. Here the dead pervade life and I'd like to linger on how De Filippo writes this traffic with the other side, through

nonsense, lack of light, confusion of speech and dialect, drawing, in fact erasing a very thin line between fact and dream, document and fiction, more or less accepted ways of communicating. After World War II, against the devastation and the loss of any certainty in Italy, the play depicts people facing an abyss, no longer able to understand those around them and their own selves, wrapped in a dark light where unsettling dreams invade reality and affect it.

The evidence of a murder, witnessed by the main character Alberto Saporito, shakes the safety of a very shaky family in Naples; it messes up communication, unveils mistrust, triggers deceit. Early in the play though, Alberto no longer appears to be certain as to whether he actually witnessed the murder.

Perhaps he dreamt of it.

What follows is a subtle play on the edge, not only of truth and fiction but of language and misunderstanding, trust and disbelief, listening and inner voices. From the outset Alberto's claims are grounded on his recalling seeing evidence of the murder—evidence that he cannot find, and that everyone else in the play is eager to see and touch. If the evidence is there, then he didn't dream. If he didn't dream, then a murderer is around and very close. If he did dream, then an even more harrowing reality of mistrust, betrayal and disillusionment among the other characters is at play, affecting and disturbing in spite of the unreality of its trigger.

When evidence fails and is in doubt, when it can neither be seen nor touched, it's time to listen. Inner voices, post-war and post-nothing, open up the space of aural explorations: they uncover another layer of reality, even more unstable, buzzing with questions and doubts. Sound takes centre stage although it's invisible, and holds together the play in an uncertain riddle. The evidence for the murder might or might not be there, but voices in the family certainly resound. A character in the play is certainly there although we cannot see him: we can only hear

him. His name is Zi' Nicola, Uncle Nicola, also known as *Sparavierzi, shooter of verses*. For a long time he has chosen to stop speaking, and to only communicate with those around him by exploding crackers and bangers. Listening to him offers another key into the entire play, as it conjures up an unresolved, complex space of transformation that bounces any demand of evidence onto the listener: there is no unique key into a stable truth, only sibylline outbursts of sounds and multiple possibilities for meaning in listening. The only way to stability lies in mutual trust and proximity, and since these have long disappeared the world of the characters in the play is shaken, under constant threat of vanishing.

I am drawn to Zi' Nicola's sounding and refusal to speak, his nonsensical commentaries on the absurdity of the world he lives in. I flip through the script of *Inner Voices*—no bronze or clay here, but words on the pages of an old book—in search of the sentences that speak of his choice:

He won't answer me.
He can't answer me.
Is he mute? No, he's not mute... He's chosen not to talk.
He's been silent for years.
He says it's pointless.
He says, because mankind is deaf, he can be mute.
Not being able to express himself verbally he finds an outlet in shooting bangers.
That's why they call him poetry shooter: they say his crackers are pure poetry.
He's an extravagant.

Zi' Nicola lives on a mezzanine, hidden by a curtain. Out of sight you can only hear the explosions, in a striking example of acousmatic listening before the term was coined by Pierre Schaeffer a decade later: listening to an unseen sound source from behind a

veil—the mezzanine curtains. In Zi' Nicola's case though, we do know what the source is even if we don't see it. There are no claims for reduced listening or sound purity: the explosions of his crackers mess people's minds up, they set the room and the entire building of understanding on fire, with no claims for clarity in understanding. Figure it out yourselves, he seems to say, take responsibility in the making and unmaking of meanings, look around and consider your history. He breaks his ultimate aphasic loop right before he dies, when he shouts later in the play, *Will you please be quiet, I need silence.* It is not by chance that after his death, in a final attempt to trespass the dualism of truth and reality in the bipartite space of the stage between darkness and light, truth and fiction, Alberto—the only one who used to be able to understand Zi' Nicola's non-verbal communications—hears from afar the sound of crackers, one last time, and this time he really doesn't understand. In a run-down flat in Naples, at the end of War World II, after the bombs and destruction he looks at the horizon, listens or pretends to listen, and whether either is true no longer seems to matter anymore. There is no illusion of kinship. All the sounds are in his head and he's alone.

* * *

Inferno

In Naples, at the end of World War II, after the Allied Forces have taken over a city overtaken before them by despair, derangement, confusion, Malaparte looks at the horizon. He hears the sea and has no illusion of relations or kinship.

The sea stared at me with its great imploring eyes, panting like a wounded beast; and I shuddered... and I trembled with horror and pity. I was weary of watching men suffer, of watching them drip blood and drag themselves groaning along the ground. I was weary

of listening to their laments, to those wonderful words that dying men murmur, smiling in their agony. I was weary of watching men suffer, and animals too, and trees, and the sky, the earth and the sea... And I trembled with pity and horror as I heard the hoarse lament of Vesuvius floating through the upper air.

In his impetuous, visionary and moving novel *The Skin*, published in France in 1947 at the end of World War II and soon censored by the city council of Naples, Curzio Malaparte writes of the city as a rotting cadaver, whose dreadful silence is intermittently crossed by whines and low hums, black wind and ashes, where every semblance of pleasure is turned into affliction and hell takes over. *Not a voice was to be heard, not even the crying of a child. A strange silence brooded over the starving city, moist with the pungent sweat of hunger.* It is a silence laden with heavy premonitions: it's time to deal with the dead, it's the hour of the dead when the municipal cart goes from street to street, alley to alley, to pick up corpses. *A vague murmur, which gradually swelled into a deafening uproar, arose from the alley, and an ear-splitting hail spread from hovel to hovel.* A crowd breaks into the Ospedale dei Pellegrini to finally see and touch the cadavers of friends and relatives *silently, like a pack of wolves, panting, gritting their teeth... they burst into a terrible cry, and halted petrified with horror.* Pyramid of heads, a heap of disfigured bodies, and then—in one of those exceptional encounters sometimes experienced in reading, when the fabric of a writer's text appears tinted by another's, and it's not about quoting but about how certain constructions of words impress one's very fabric of thinking-reading-understanding into writing—I hear Dante's words echoed in Malaparte's: *With loud cries, frantic wails and savage laments the crowd threw themselves on the dead, calling them by name in voices that were terrible to hear.* Hear Dante in *Inferno*, Canto 3, on entering the gates of Hell: *Here with loud cries, sighs and wails, resonated in the starless sky... various tongues, terrible voices...*

Later in the book such hellish visions become more and more grotesque, sharp and disturbing, peaking in the pandemonic climax of a chapter entitled *The Rain of Fire*. I have found no mention of Malaparte being familiar with the paintings of John Martin, but his account of the last great eruption of Vesuvius in 1944 during the war bears similar apocalyptic tones and overwhelming, saturated presence:

Vesuvius screamed horribly in the red darkness of that awful night, and a despairing lament arose from the unhappy city... From time to time a hollow, muffled rumbling, which spread through the secret recesses of the earth, shook the pavement beneath our feet and made the houses rock. A hoarse, deep, gurgling voice rose from the wells and from the mouth of the sewers... That subterranean rumbling, that deep voice, that boiling mud caused a sudden efflux of people from their lairs in the bowels of the earth... Those crowds of mud-stained, spectral beings who were everywhere emerging from beneath the ground... and the brawls, the yells, the tears, the oaths, the songs, the panic, the sudden stampedes... created a frightful, stupendous chaos of sound which filled the city.

* * *

Under

I am drawn to Naples via De Filippo's *Inner Voices* and Malaparte's *The Skin*—to Naples as a knot of attractions: a dense, intricate site where I can collect thoughts around the missing evidence in Writing Sound, and reinstate the presence of sounding words nonetheless. In my recollections from an early childhood, streaked with threads of imagination, with later historical knowledge and with memories of later visits that made my idea of the city more unfathomable, interred, opaque, Naples is configured as a site of burial and underground mysteries, kept together by a loose thread running across the Fontanelle

Cemetery, the cult of the souls of Purgatory, the infamous Cemetery of 366 pits, one mass grave for each day of the year, built by architect Ferdinando Fuga in the 18th century. A site of uncanny influences, as depicted by Théophile Gautier in his short story *The Jinx* (1856), the city portrayed in sick tones of illness and omen in a text imbued with Swedenborgian influence. A site of confusion and heightened perception, a site of deep time as I read in Siegfried Zielinski's *Deep Time of the Media* (2006): *There is no other place where the quick succession and chaotic whirl of moments seem so precious*, he writes in the opening pages of a chapter exploring the 16th-century Academy of Secrets set up in Naples by Giovan Battista della Porta, *not an academic in any conventional sense... not a disciplined thinker*, favouring instead *mobility and the state of being in-between* and a writing style closer to the spoken word than to discursive, exclusive form. Among a survey of experiments ranging from pneumatics to the art of memory, from maths to medicine and physiognomy, lights and projections, cryptography and *circular writing*, as I read Zielinski's book my attention stops on a lateral hint, that prompts yet another train of thoughts by pointing at a specific place: the church of San Domenico Maggiore, where Thomas Aquinas had taught and where, in 1590, della Porta and Tommaso Campanella held a public discussion on magic.

I must linger on this clue an on this place because, at the opposite end of the same piazza where the San Domenico Maggiore church lies, is another highly charged site: Palazzo Sansevero.

* * *

On 23 September 1889 in a wing of Palazzo Sansevero, a small bridge connecting the palace with the nearby family chapel collapses. The accident reawakens interest on one of the palace's accursed inhabitants, Raimondo di Sangro, prince of Sansevero

(1710-71). The cause of the collapse is a water leak but soon rumour spreads that the night before the accident, strange noises rising from the underground vaults of the palace and sinister omens had announced the imminent ruin. The palace had once belonged to magus, prince, scientist, alchemist, scholar and polyglot Raimondo di Sangro, whose legend swarms with fables of groundbreaking experiments in printing, weapon design, architecture, unlikely mechanical contraptions. Popular lore believed the prince to be in close traffic with the devil itself; to have ordered the murder of two of his servants, their bodies treated so that the architecture of their internal organs would stay as a whole and could be displayed in the family chapel; to have had the eyes of the sculptor who made the *Veiled Christ* for the chapel ripped, to prevent him from accomplishing a more beautiful work; and to have died after having asked his servant to cut his body in pieces in order to test an experiment in resuscitation—a Neapolitan Doctor Faustus, in the words of historian and philosopher Benedetto Croce.

At the end of the 16th century Palazzo Sansevero was the house of one of di Sangro's ancestors, madrigalist Carlo Gesualdo, who murdered his wife Maria d'Avalos and her lover Fabrizio Carafa in one of the rooms of the building. According to legend you can still hear their voices through the walls, whining and screaming in despair, merging with the sounds from two centuries later, from di Sangro, his forge and his experiments:

Stubborn and long noises would resound from within; from time to time, in the dead of the night, you could hear the clinking of an anvil struck with a heavy hammer, or the street floor was shaken as if passed through by invisible huge carts.

When I visit the Sansevero chapel all is quiet. I tune in remote voices, I descend, I am the drive downward, the basso continuo in the madrigal. The chapel is a network of references around the

city—not much in space, but across history. I recall some words by Harry Partch:

> *It is one of the purposes of scholarship to discover ethical values and disciplines out of the past, verbally and visually stated, and to preserve them. I care a great deal about contemplating an age or ages that have been discovered through digging and presuming and learning. But I care even more for the divination of an ancient spirit of which I know nothing.*

This is how I am drawn to sounds. I know nothing of them, they whisper from the edge of my understanding: *spend time with me now.* And then I recall, then I write and the words that follow will not have a punctum, they will trace instead an extended arc of kinships, in various degrees of closeness or distance, opacity and clarity, and the evidence will never be there, and it will be always be on an edge, tipped over toward the multiplicity of singular and contingent ways of listening.

From these prompts—extraordinary, alien or vaguely familiar as they might seem—I see Writing Sound as an arrangement of recurring obsessions and their cadenzas. In Writing Sound I no longer think of research but of a gathering, assimilation and relay: a miscellanea of words, the site where points are unmade: outside of sound, having listened, in writing. I remember Allen S. Weiss making a case for the poetic potential of ellipsis as a device that at once interrupts and unlocks—fantasy, desire, imagination... listening? *The gap is the place of the tale.* The gap between sounds and words is the place of the tale of Writing Sound: a tale which often is just a beginning, or an end, or has no plot, where a sense of time unfolds, not kept but spent, not concluded but rough at the edges and embroiled, looped, where listening is not only to receive but to take part in the making of kinships, and to write sound is not to create anew, explain, clarify, but to extract from layers of other words, to fabulate, circulate, to lull sound in

the throat in reading aloud and whistle it in the mind—to move, and to move.

* * *

This chapter can only end on a gap, on a title, followed by no actual chapter but rewinding back on to the previous pages:

Sound is as Real as *Hell* (after Dante)

12.

Kinships

As I tidy up papers on my desk I find three old printouts from book orders at the British Library: a series of bibliographical *derives*. Actually no tidying up can occur here, no book plan or sequence can emerge: these are lists of thinking through listening into reading, trajectories that in their apparent randomness take me back inside the drive of my words, looping and clustered around some recurring, still missing core.

16 April 2013
My Reading Room Requests.

1. Janet, Pierre Marie Félix, *De l'Angoisse à l'extase. Étude sur les croyances et les sentiments* (1926).
2. Duncan, Robert, *The Opening of the Field* (1960).
3. Leiris, Michel, *L'Afrique fantôme* (1934).

12 March 2013
My Reading Room Requests.

1. Leiris, Michel, *L'Afrique fantôme*.
2. Cixous, Hélène, *Rootprints: Memory and Life-Writing* (1997).
3. D., H. *Palimpsest* (1926).
4. Pound, Ezra, *A lume spento* (1908).
5. Bataille, Georges, *The Cradle of Humanity* (2005).
6. Robertson, Lisa, *Nilling* (2012).
7. Agamben, Giorgio, *Profanazioni* (2005).

6 February 2013
My Reading Room Requests.

1. Leiris, Michel, *L'Afrique fantôme*.

In May 2011 I began reading *L'Afrique fantôme* by Michel Leiris. I began to read it for no reason that could be attributed to any rationale in research: I gravitated toward that book because of the echoes around it. The book is a 533-page meticulous recording of the famed Dakar-Djibouti ethnographic expedition, led between 1931 and 1933 by anthropologist Marcel Griaule: a journal that turns into a journey of self-ethnography written by Leiris, who'd been hired to be the expedition archivist and who gradually transformed his writing into a tortured questioning of the self against any univocal, solid notion of culture. I'd read of *L'Afrique Fantôme* in other books, mentioned and referred to— most of all I'd read of it in James Clifford's book, *The Predicament of Culture* (1988), an enquiry into ethnographic surrealism and *topoi* of authenticity, a study of cultures that live *by pollination*. I searched for it because of Clifford's words, describing Leiris' book as

field notes on himself, or more precisely on an uncertain existence...
Enmeshed in writing... the journal's scrupulous entries appear...
each promising that something *will somehow happen and that soon*
we will see what the relentless series is leading to... We never do.
No moment of truth... only a pen starting up each day.

As an Italian writing in English, challenged by the demands and the traps of a slowly crumbling subjectivity as it morphs within a different language, my words stuck in the loops of beginnings that begin nothing, I was tempted.

No English translation of Leiris' book exists. My understanding of French is poor and intermittent, and I would spend

days at the British Library in front of those pages—not reading them, not even claiming to translate them, but listening into reading them, like far horizons of understanding, at times as they became transparent, at times impenetrable, at times offering me half-guessed openings toward other horizons: they were at once my challenge, mirror and demise. After three years of sustained experiments I can say I did read that book; did I succumb to it? Meanwhile I listened, and meanwhile my pen too would start up each day, to record the motions and detours of my listening to and with that book. I've been in its company, in its proximity, trying to see what sort of words might grip over it, leak out of it, erupt out of the lines of my inner monologues inevitably attached to its form. I enjoyed the moments of transit from a half-guessed clear text to a half-guessed diagram of ghostings, when the text became an intermittent sounding box ready to echo in turn my thoughts, my words. I listened to it. I was excited when I heard myself as I read:

Truly a human measure, my horizon.

Spinning around the shifting horizon of reading, in the thread of every word in *L'Afrique fantôme* I hear what is not there and I make what is imagined, actual: an escape out of fixity. This listening-reading-writing space of mine—where *mine* is not only possessive, but a site of extraction—is not a site of lack of understanding. Listening-into-reading-into-writing seeps out of the borders of given codes, where margin becomes a mark in passing, a metamorphosis. As I read, listen and write a sense of time unfolds, not kept but spent, not concluded but rough at the edges and embroiled, looped. I turn to the inaudible and the unreadable in these pages, beyond the pages as objects, to words spoken by the mind as I listen, when listening is not only to receive but to actively take part in the making of kinships, and writing is not to create anew, explain, clarify, but to extract from layers of other

words, to fabulate, to circulate sound in reading aloud, to mess it up, to lull it in the throat and whistle it in the mind: to move, and to move.

* * *

What does Leiris always do with language anyway: he does not explain, he listens to it and rearranges its materials around a life, as in *Scratches* (1948), the first volume of his autobiography:

> *Misapprehensions, errors about the very texture or the meaning of a word, phonic analogies creating a network of strange relations between one term and another... the evocative power of some vocabulary names... the double aspect of words that have a meaning for us that does not necessarily agree with the definition given in the dictionary, various types of accidents of language... such is the group of fragile but intensely felt realities... I was collecting and that formed—without my leaving, at first, the verbal domain that was still special for me—the original core around which the rest gradually solidified.*

On 10, 11 and 12 November 1931 Leiris visits the village of Yougo, *La Rome lunaire*: lunar Rome, he calls it. I read:

> *Un paysage... de fin du monde. De pierre en pierre, de lieu sacré en lieu sacré, de cave en cave... Ici, tout n'est qu'abîme, plein ciel, ou souterrain.*

And the word that resonates mostly, while I read this semi-opaque screen of meaningful words and expressions such as *fin du monde, cave, abîme, souterrain*, is *pierre*.

* * *

Some time ago I got so close to another book at the edge of under-standing—so close to it that I let my words live inside it, and come to life out of it. This book was *Pierre* by Herman Melville: the book he wrote after *Moby-Dick*, a complete fiasco, deemed illegible after it was published in 1952 (*the ravings and reveries of a madman*, according to one review at the time), a book that points at the borders of writing, the story of a reader who attempts to become a writer:

> *How swiftly and how wonderfully, he reads all the obscurest and most obliterate inscriptions he finds in his memory; yea, and rummages himself all over, for still hidden writings to read.*

Pierre is a book shaped around the conflict between the impossi-bility of conveying any profundity in writing, and the tension to write out of a profound drive nonetheless. It subtitle, *The Ambiguities*, marks such condition, reinstated across its pages:

> *Far as any geologist has yet gone down in the world, it is found to consist of nothing but surface stratified on surface. To its axis, the world being nothing but superinduced superficies. By vast pains we mine into the pyramid; by horrible gropings we come to the central room; with joy we espy the sarcophagus; but we lift the lid – and no body is there! – appallingly vacant as vast is the soul of a man!*
> *...For the more and the more that he wrote, and the deeper and the deeper that he dived, Pierre saw the everlasting elusiveness of Truth, the universal lurking insincerity of even the greatest and purest written thoughts. Like knavish cards, the leaves of all great books were covertly packed. He was but packing one set the more; and that a very poor jaded set and pack indeed.*

When I say I read *Pierre* I do not mean any copy of that book though, but an old Italian edition from 1942, containing ten blank pages where the ink is missing: you can see the imprint of the

letterpress on those pages, but by mistake they were never filled with ink. For months I have worked inside this book, opened its blank pages and found unexpected patterns in-between them and the thickness of Melville's prose around them. I have under-lined over twenty-five sound-related words across two pages and used them as prompts to write a text on listening; I have stared at the blank pages while repeating in my head the phrase *for still hidden writings to read* over an hour; I have used the book as a prop during readings and presentations, pasting cut-off pages from my texts in it, letting its words infiltrate the texture of my reading aloud; I have been in its company and recalled Lydia Davis' remark, about translating Maurice Blanchot's essays in *The Gaze of Orpheus*, that *understanding became an intensely physical act.*

* * *

My listening to, reading, writing in and off Leiris' and Melville's books as they become mine might be evident at this point, but what did I give to the books in turn that made my relationship with them symbiotic rather than derivative? A tentative way to begin an answer might come from another word that I read in that loaded sentence of Leiris' quoted above, and that caught my attention like a crystal in the mud, in a mine: *abîme*. A word that appears in *Pierre* as well as *abisso/abyss*, and that tempts me to follow its triple-shaped assonant prompt: *abîme, abisso, abyss*.

Mise-en-abîme is a way to reclaim references inside my writing, to make them part of it and not just footnotes: to dismiss frame-works of legitimisation and give words meanings inside the text. If I'm close to a certain French word in Leiris and echo it in my writing in English, as I hear it through the hybrid lens of an acquired language, its sound also reaches out to those who might not detect it as a labelled entity: to those who might not know I read it in Leiris, but hear it and understand it nonetheless. This

type of understanding doesn't have much to do with recognition, but with listening to and through, attending to, spending time with words; it is the same type of understanding that Robert Duncan writes of in *The H.D. Book* as reciprocity, necessity, kinship.

Out the reading abyss of *L'Afrique fantôme* and *Pierre*, out of phantoms and ambiguities, such kinship is brought to surface. It is made alive inside writing: not as index, pointing at an external system of references, but as a *bringing back* (*referre* in Latin). The resulting writing is jumbled and embroiled, inevitably historical, it keeps time in its very making and it keeps it out of synch from its memory. And when W.G. Sebald writes that sometimes, when coming across certain recurring references, *one has the persistent feeling of being beckoned to from the other side*, I can only think that it is crucial to keep these voices from the other side heard: every time we choose a reference, we choose to keep certain voices heard — those, not others — and these choices matter in the way writing is positioned within the drift of marginal cultural backgrounds.

In his book *Sound and Sentiment* (1982) Steven Feld writes of how, while doing ethnographic fieldwork in Papua New Guinea, he became riddled as he attempted to classify birdsongs. One of his Kaluli guides told him: *Listen - to you they are birds, to me they are voices in the forest*. The references within a text are not birds to recognise but voices in the forest, to be heard before knowing what they are. In their intricacies, they claim first of all to be heard — to borrow Davis' words again, they demand *physical understanding*. They are not markers of something else: they *are*. They contribute to the meaning of words there and then, they prompt to wander and get lost in them, not to classify them. They invite readers to wander in their own forests too. My readings of Leiris and Melville are some of the voices in my forest through which I have listened, understood and written. They are not caught in the stillness of classification but move across my history of reading them through sound.

And when I say history, it's not a history with a capital H but a small h: the aspiration in the h of history is echoed in the h in ephemeral: a whispering, a transience.

* * *

I wrote of reference as material, now I'd like to switch from material to medium: a space to connect. My medium is listening onto writing and back, writing onto listening: *there* I connect. Medium is also illusion, and trick, and risk. Is it listening to, or listening through? Illusion, or understanding? I can never describe a sound, I can write sound: I can build a frail yet precise cobweb of words and cut-off blanks. I write, and each word is accompanied by an underwhispering. It is no longer *I* writing, but *they*. I begin to wonder about this system of tricks and echoes and relays in writing/listening: like Dante in *Inferno*, Canto 13, when he's lost in yet another forest, and hears disembodied voices as their souls are caught in the trees, and there is one verse that goes *I believed that he believed that I believed*, I think of echoes and mishearings that write.

* * *

The question I want to ask is not what binds these lost, guessed, received or imagined words together, but how the invisible, less evident thread of listening moves through them. It is not a clearly and coherently laid out plan, to listen to these words at once, but a mapping of attractions that I make in a specific historical time, in response to their pressures. So the attention dwells on the peripheral—accidents of hearing, detours of thought—rather than the assumed core, up to the point when the very core of my writing becomes what is normally deemed peripheral. I seek to reclaim the complexity and intermittent incoherence in this reading-as-listening, and to work with its residual aspects, those

thoughts that are often dismissed as irrelevant.

* * *

I no longer consider myself a writer, a theorist, a critic: rather, I am a handler of words, a listener, a reader. In this web of ambiguities and phantasmic presence an intricate thread is woven. For both of these books, the question is not, *what does it mean?* but *what becomes meaningful through it, and how?* Looking, finding, reading, listening, writing, are ways to bring their words together and hold them in a precarious network of associations with my words for some time, not forever—to make connections, among words and stories and recollections, always singular and fleeting, yet always open to be woven in turn into further voices and responses by others. In a hushed and profound manner, these books prompt me to let them circulate, so that once they have been cast out to others, as Leiris would say, *they will come back to them a little more magical, like the shields of the Northwest American Indians, which are endowed with greater and greater value the more often they have been the object of ceremonial exchanges.*

* * *

The peripheral positions of my reading and listening to these two books, reflected into my writing, open up a sense of experiment; they are ambiguous in a provocative manner. They do not speak directly. I can draw from them and write, if I stop considering what they can communicate clearly, and think of them as conglomerates of word-thought-material out of which further words can be extracted, not created anew. A spinning force moves the resulting words, fuelled by a sacrilegious aspiration to be sound. They never encounter a climax but they take shape and re-shape, whispering their h and histories in passing, running under the thickness of thoughts.

13.

The Record Itself Doesn't Matter

What are the boundaries of an object? Is an object a living thing, an idea, an event that lives in many kinds of time? How can an object be described? Can we undo centuries of conditioning and experience objects as events? How can that which seems not to be an object, such as sound, exist in the same world as that which seems to be an object, such as a musical instrument? Is the sound of a turning page an object, or the air from a plastic USB fan? Is a gesture an object? Where is a moving object an object? When an object becomes memory or loses functionality, does it stop being an object?

I read these questions in an email by David Toop, introducing his thoughts around an event called *Beyond the Object* and inviting me to contribute. As I look at the questions I hear doubts as to my possible answers; in my attempts at writing, words fail me. Other words appear, in the space of reading: my response swarms with references to texts that describe impossible objects or unlikely sounds and I have no words to add to any of them, rather I become absorbed in anticipating the way all these texts could work together, myself functioning as a mixing desk that fades them in and out, arranging them in a continuum of reading. In the end I tie up a string of textual fragments as possibilities for further inquiry; not on a page to be filled with words, but filling the space of reading aloud with pages and words written by others.

In distracting myself from writing and in shifting the attention to reading, reading as sounding becomes my response: leaving writing aside, I let all my references for a text that will never be written emerge, in the space of reading aloud as presence.

* * *

At the time I receive David's email I'm reading *Água viva* by Clarice Lispector. I find out that the book's two previous working titles were *Beyond Thought* and *Loud Object*. In an exercise of subtraction, in response to the invite to *Beyond Object*, I focus on *Loud Thought:* thinking aloud. And because the objects of my thinking are books, I have to consider them again, read them aloud, thinking through reading, sometimes scream.

What am I in this instant? I am a typewriter making the dry keys echo in the dark and humid early hours... They wanted me to be an object. I'm an object. An object dirty with blood. That creates other objects and the typewriter creates all of us. It demands. The mechanism demands and demands my life. But I don't obey totally: if I must be an object let it be an object that screams... But tears are missing in the typewriter that I am... What saves me is the scream. I protest in the name of whatever is inside the object beyond the beyond the thought-feeling. I am an urgent object.

Soon another demiurgic typewriter echoes in my reading, it's Gert Jonke's in *Awakening to the Great Sleep War*, at that point in the book when the main character Burgmüller finds out his girlfriend's typewriter functioning for her as if it was *a reality-producing projector*:

Unflustered, she crouched at her typewriter, into which she trans-mitted her tapped signals as usual long into the night, continuing the work on her world, in which her eyes now became a compass rose torn by its own magnetic needle, cut up as if by the letters of a white-hot cuneiform script of the harbor cities that reproduced themselves incisively upon all the coasts with their power-saw boats, in the service of an endless alphabet, like a science without proofs...

Writing Sound too is a science without proofs or fixed objects: marginated, marginised, edged, boundaried out of a missing core. There might be no object even, at its beginning or end: there are sounds, beyond the fixity of a recording support, and there are words that know nothing of themselves other than that they are. In transience I relate them, passing, listening, connecting them and myself and who is there to hear. At the end of objects, where I see a cut, the turn of a page, the edge of a book, the end of a song, there is echo and return. No need to consider sound as heritage or site of permanence: rather, a call to imprint the ephemeral matter of sound with time spent, an incessant transposition of the tangible into an intangible matter.

* * *

Then there are objects as vessels of ritualistic investment, passed on by people across time: the more they are collected and relayed, the more they function as escapes out of fixity, prompts to connect, points of attraction, friction, contact. During a recent visit to the Pitt Rivers Museum I lingered among the empty drawers and the glass displays with no aim to hit, or point to make, or specific object to see: rather, open to encounter and unpredictable discoveries, like this writing. My eyes were drawn, in the *Magic Charms and Amulets* displays, toward a desiccated onion, *with a name written on a piece of paper, the whole stuck with pins.* I think of Writing Sound as of those thin splinters of steel, adding on to what once was a juicy core.

* * *

In April 1929 when the journal *Documents* had published only one issue, Pierre d'Espezel sent to George Bataille a sarcastic note: *The title you have chosen for this journal is hardly justified except in the sense that it gives us 'Documents' on your state of mind.*

I am drawn to objects when they are broken, unreal, imagined, dreamt or nightmared: object-documents that are no longer there or never have been but tell states of mind, like in the narrator's dream in Nabokov's *Lance* (1952) caught at the very edge of words that cannot capture the object and yet speak, around it and in spite of it.

When I was a boy of seven or eight, I used to dream a vaguely recurrent dream set in a certain environment, which I have never been able to recognize and identify in any rational manner, though I have seen many strange lands. I am inclined to make it serve now, in order to patch up a gaping hole, a raw wound in my story. There was nothing spectacular about that environment, nothing monstrous or even odd: just a bit of noncommittal stability repre-sented by a bit of level ground and filmed over with a bit of neutral nebulosity; in other words, the indifferent back of a view rather than its face. The nuisance of that dream was that for some reason I could not walk around the view to meet it on equal terms. There lurked in the midst a mass of something - mineral matter or the like - oppres-sively and quite meaninglessly shaped, and, in the course of my dream, I kept filling some kind of receptacle (translated as 'pail') with smaller shapes (translated as 'pebbles'), and my nose was bleeding but I was too impatient and excited to do anything about it. And every time I had that dream, suddenly somebody would start screaming behind me, and I awoke screaming too, thus prolonging the initial anonymous shriek, with its initial note of rising exultation, but with no meaning attached to it any more - if there had been a meaning... But the funny thing is that as I reread what I have set down, its background, the factual memory vanishes - has vanished altogether by now - and I have no means of proving to myself that there is any personal experience behind its description.

A quasi-object, dreamt and written. A doubt around meaning, except for the meaning given by its description, echoed by a

doubt around an experience even, *behind its description*, on the threshold of believing that any personal experience occurred. I want to hold on to this moment and keep it as a thread throughout these pages: the hesitancy in *if there* had *been a meaning*, the silent scream of the dream made louder in the echoing listening room of our minds, recollections, dreams.

Of my childhood dreams, one of the most insistent... was based on this very simple theme: the search for a known object that had been lost for awhile and that I ardently wanted to recover. A dream of pure desire, which I still have now and then in various different forms and in which the object I must put my hand on again is usually a gramophone record. An absolutely marvellous record... that I recall having heard though I can't manage to find it in the heap of other records I have also listened to recently; a real record, but one that can't be found (even though while I am in the grips of the dream I have no doubt that it is close by); a single item lost in a collection comprising many other items not without value, though they are nowhere near comparable to the one whose lack is a severe hindrance - if not over a longer period of time, at least for a few minutes - to my feeling happy... Not that, as I dream this dream, I exhume an ancient dissatisfaction, untouched since it first came into being and molded in the exact same container: a solid body without thickness, holding potential sonorities, even though in its design it is small enough to be put it the mail. In the dream I have now, the record itself doesn't matter... No need for this instrument... to have any other meaning than that of music.

In Leiris' dream of the object, desire is paramount and again, a dreamt quasi-object holds a special untold and unheard sonority. Meaning and music, meaning and sound, meaning and listening appear tied together, the object is not quite an object but a dreamt entity whose borders merge with the writer's thinking-writing until it is no longer clear what is being dreamt and who

or what is writing, what it means, what means and what makes meaning. As the dream-object appears in the first volume of Leiris' autobiography, *Scratches*, the nature of the dreamt object as a vessel for changing meaning gains another layer as it wraps around the telling of a self that is shifting, transient and moved by desire. Desire and loss, like the episode with the glove that unsettled Breton in *Nadja* (1928), opening a gap between a real sky-blue glove used by a lady and a bronze glove that she gave to him instead; or like the object-soul-cursed-jewel in Arthur Machen's *The Inmost Light* (1894), an opal that holds *a wonderful flame that shone and sparkled in its centre*, in fact the soul of Agnes having agreed to give her life in a fatal pact with her husband and his experiments.

What binds these quasi-objects together across time and back onto these pages? A sense of unfolding, a correlation of reading, writing and listening in a state of transience. In writing, in frictions between and because of time, I welcome the interpretive delirium derived when objects lose their function tied to habits: no longer sites of permanence, through listening they evoke a spectrum of possibilities and then, they elicit words as spectres.

Leftovers:
From the Notebooks on Writing Sound

One of my favourite books as a child was *Lamberto, Lamberto, Lamberto* (1978) by Gianni Rodari. It is the story of a rich and very old man who lives in a mansion on the island of San Giulio, in the Orta Lake in Northern Italy. Afflicted with many illnesses, he consults a number of experts until he suddenly begins to get a lot better. Early on in the story, the reader finds out that the secret of the Baron's longevity is a group of employees, hidden in a room in his mansion, hired to pronounce in shifts his name, night and day, day and night, ceaselessly, thus keeping him alive. Following the advice of *an Egyptian mystic* who'd advised that *he whose name is spoken, lives forever*, the Baron sets up a system of pipes throughout the building, into which a stream of *LambertoLambertoLambertoLamberto* is spoken uninterruptedly. At all times he can listen in, and make sure he's going to be alive, forever.

A twist in the story casts a sinister shadow on the notion of voicing and listening as life. In the end, after a series of adventures including a group of terrorists who invade the island and a nephew who plots against the Baron's life and murders him, Lamberto is resuscitated by hundreds of people speaking his name during the funeral, triggering a paradoxical and grotesque process of rejuvenation. He becomes a strange character at the beginning of listening, as the promise of winning time through sounding shrinks his body into little more than a child: a nemesis of sort from listening, an extreme consequence against any claims for permanence.

* * *

The recorded voice speaks through itself, it speaks to nobody in particular and to everyone who listens. A perverse illusion of permanence. In *Brighton Rock* Pinkie goes into the recording booth in spite of himself, as his new and hated wife Rose asks him to record his voice because he'd never given her anything thus far. *He didn't like the idea of putting anything on a record: it reminded him of finger prints.* Rose and Pinkie don't own a record player, but to Rose it doesn't matter whether she'll be able to play the disc or not. *I just want to have it there.* Pinkie records harsh words of hatred for Rose, while nobody is listening but him. The record is never played, events unfold.

At the end of John Boulting's 1947 film adaptation of Graham Greene's book from 1938, after Pinkie has died, we see Rose convalescing in hospital as she puts the disc on a record player borrowed from another patient. I shiver in the anticipation of the dreaded moment of revelation of her husband's loathsome words. And yet the needle gets stuck on a loop, sounding a locked groove of Pinkie's *I love you, I love you, I love you* before his harsh words of hate: those words will always be contained in the record but will never be pronounced or heard.

At the end the book we are left instead with the dreadful implication that Rose will in fact hear the whole recording: *There was something to be salvaged... his voice speaking a message to her... She walked rapidly in the thin June sunlight towards the worst horror of all.* An unresolved final ellipsis, an unwritten moment of change teased by the ambiguity between the presence of a voice and the death of he who spoke. This seems to be a much more harrowing condemnation for Rose, in print or in film, as the underlying fact of death and absence shatters any hope. The voice in the record speaks through itself but it does not speak to anyone in particular. Each present tense in a recording needs a relationship when it is played: it needs a listener to rewrite its history. We edit the sound of each record and of each memory into the framework of our presents. Degrees of editing are

sometimes intentional, sometimes occasional. How do we accommodate these accidents? How do we edit listening into life?

* * *

It happens at the end of a long seminar. One of the participants starts talking to me, discussing something meaningful for her, relevant to the discipline. Instead of following her words and reasoning along them, I linger on the way she pronounces the letter R—a velvety rounded trill that wraps a soft veil around her sentences—until I find myself completely immersed in this whole other world of listening, with no idea of what she's talking about but certain that talking she is, herself and the velvety rounded trill.

I want to claim this dimension of listening, into my writing: this accidental freedom to linger, to encounter and surrender to unexpected points of access. To be inchoate, unprepared and amused, like on hearing the sound of that R and getting lost in the sound of it beyond sense and toward another sense.

* * *

I want this to be sensuous. I want it to be footnote and reference. I want this writing to be footnote, the murmuring voice that speaks from the bottom of a page, to be heard as it tears itself off the hushing dumbing heavy fabric of logic wordy linear writing. I want this writing to be reference, the absent living matter that holds a promise of contiguity.

These words come to me one afternoon in the British Library as I read yet another book on listening that works through a clear arrangement like a smart game of join-the-dots, smothering the sounds and the words it writes on, squeezing its material, its references and footnotes out of itself, making them more remote and disconnected.

I long for another writing, of sounds and of else. I search for words made through reading and through listening as flows of thinking-feeling-writing: not *on* texts and sounds as objects. I search for my writing too, with them. It is doubtful and sometimes even dubious, this dusty writing, this swept-under-the-carpet writing of mine. Its main concerns—listening, reading—are ephemeral and cannot be kept. Its main concerns are ghosts, the writing that ensues is a passing presence, a trick.

* * *

I cannot read and not write. I cannot write and not read. The two are conjoined and necessary to each other. Next to each book, a notebook. On the pages of each book, adhesive paper marks, lines, arrows, asterisks. On the screen, an open document to transfer, transcribe and remark more words. These days the ephemerality of reading grows even less tactile because of iPads and tablets. The fact of not being able to make notes on their pages, to leave a mark on them, channels the space of my reading more directly onto more writing. Annotations have no longer any room around a text, hence they move onto another page into a new beginning. What once would have been marginalia migrate from the margins to the core of some new writing.

* * *

Writing these notes I am driven to books that have become part of my thinking-writing space. They are all here, not in a studied bibliographical order. They are here because they please me, because they complicate my thoughts and my listening, because I write with them and because of them, because at times they quieten me and other times they provoke me. Because with them I trespass my borders. Writing becomes, as suggested in an email by Craig Dworkin, *a differential operation of subtle variance* through

kinships. It reinstates now, every now, what is urgent: not always new and original, but urgent.

* * *

This-curse on the method

I have always written intermittently and at times I have greeted being summoned to write by a persistent thought or an irritating prompt. I have not sat purposefully in front of a blank document for months, I have no longer programmed long writing hours: instead, I have been scribbling on notebooks and typing on my laptop, iPad and even my phone. Writing with what is around and anywhere I am.

I never felt I had made an agreement with anybody for writing. In this sense, I am reluctant to call it work: rather, I have written off dictations and rearrangements. I play in them and I am withdrawn from them. I am not expressed in these words, I impress them every time and then disappear and others will take their space. Reading and listening are secret empty spaces out of which nothing can be derived other than the relationships, conversations and connections that they host. They meet life. Outside of their edges, reading and listening meet life and there they speak, sound and gain presence again. Away from themselves, in transformation.

* * *

On reading *Água viva* by Clarice Lispector I become silenced. How can I move on after encountering words such as these that coincide, edge to edge, with something so crucial and leave me speechless because at this point the only action I may want to take is to become cavity, contain them for a while and echo them?

The secret harmony of disharmony: I don't want something already made but something still being tortuously made. My unbalanced words are the wealth of my silence. I write in acrobatics and pirouettes in the air—I write because I so deeply want to speak. Though writing only gives me the full measure of silence.

I don't want to have the terrible limitation of those who live merely from what can make sense. Not I: I want an invented truth.

May whoever comes along with me come along: the journey is long, it is tough, but lived. Because now I am speaking to you seriously: I am not playing with words. I incarnate myself in the voluptuous and unintelligible phrases that tangle up beyond the words. And a silence rises subtly from the knock of the phrases.

How could I move on from this, so near to the heart, so very close to my innermost thoughts to the point of utter desire?

I do not move. I stay, and very close. Only so, I might begin again to articulate my words again. Gently but with intent. Not on and from her words, but under and aside them, splitting their edges with the fine blade of my hearing, and listening between the two thin layers, curious as to what faint voice I can hear through them.

The faint voice murmurs to me: aside and with.

The faint voice murmurs: write aside, listen in, write with.

The faint voice pushes me one slight bit aside, with and toward another silence, toward another resounding void: aside, in, with.

Only then will the thoughts that surround these words resound, other than these words. They will give rise to a different experience because of our singular, different lives. I can only start writing again from the nebulosity of thoughts that spring out of these so-close words of hers. I can hear a pool of thoughts circulating amongst them. As I tune in, I hear as much the hum of their shared space as their different pacing, the ebb and flow of words triggered by her words. On the borders I encounter a self and in the end I encounter a history.

* * *

At the National Gallery, in front of Sandro Botticelli's *Mystic Nativity* and its flatness, I consider the incoherence of big and small figures in the picture; there is not one point of convergence but a delirium of zigzags. Its rhythm holds all, it converges and diverges, at one point it is broken and then it starts again. The arrangement of colours too is flat, like a woodcut intarsia. Art historian Giulio Carlo Argan wrote that this painting is a gesture, obscure and arbitrary, with no logic and no history. Or: history is no longer lesson or authority, but a poetic space to inhabit and reshape. Writing Sound could be like that space, not ordered but heard; it is the dimension of a historical now. It happens in simultaneity. It is not a description of absence, but a construction of presence.

* * *

In *Awakening to the Great Sleep War*, Gert Jonke writes sound. The traffic between words and sounds has never appeared so fragile, in change and shaken by an endless questioning of their mutual positions: sounds take the temporary forms of fantastic constructions, words appear before they become sentences. The book is an unstable receptacle of these fluxes; I am captivated by the unlikely yet nagging idea that all the words in the book might slip off the pages as I read them. What would it be like to rearrange them? Words chase sounds and they flow away in a fugue of sense and of senses that remakes sense in listening through a string of delirious yet sharply conveyed associations. Even caryatides and telamones listen to Burgmüller, the main character, an acoustical decorator; a fly called Elvira listens to hums that we're less aware of as humans. The book stages a constant questioning of language in front of sounds as it shapes, misshapes and transforms identities. It's a book of metamor-

phoses and digressions whose initial forms have long been forgotten, like in the hilarious pages where Burgmüller talks to one of the women he falls in love with, on a train—a nonsense marathon hooked on the paroxysmal reiteration of HITHER and THITHER, where the origin and destination of the journey are forever obscure and where words scream to be read aloud. The troubled relationship between listening and language is at play. At one point Burgmüller realises that, unable to perform his *acoustic space project*, he is only left with words. So he begins to talk and talk, and countless sentences pile up, each of them ending with *just imagine!* as he incessantly attempts to build experiences of listening through words. Just imagine.

* * *

Read Patrick Farmer's book *try i bark* (2012), be drawn in and pushed out of its pages, to absorb the environment around you. Be washed away from these words just like you can be washed away by an encounter with a landscape, soundscape, wordscape, all entangled and there is no way or reason why you should be singling out *the* sound or stuck in a solemn pose of *all be still, I'm listening!* Listening here reads as reading it hears as seeing. Nothing to decipher behind the words and the blanks on these unnumbered pages, no hidden codes to reveal an authentic or authored sense: sense exists as words are resonated surface by surface, layer by layer, bark by bark. *This book is to be read out loud and outside*, Patrick says. *Delichon urbicon, apis melifera.* Speak out Latin nomenclatures, broken rhythms: even when their form is recognisable their meaning shifts, they're not signifiers but sounding signs, they echo and echo between knowing and doubt and knowing. Speaks speaks speaks speaks. Try and read out *try i*, try *i bark* as sound, think *bark* as sheath. *try i bark* elicits no synopsis or crucial points, the entire book is crucial and its flipside is in the ordinary, in passing: it exists in every reading as

an encounter not only with environments, but with words. Meet them on these pages and watch their shapes, sound them in reading, to the point of no longer feeling safe in knowing: Farmer calls it *being part, not separate part*. *try i bark* performs the exhilarating and unsettling moment when you write or read, and realise that shapes, words, rhythms, sounds do not come from a blank sanitised within, but contaminate, affect and call you from elsewhere: you contain them and they you, and the pages are the edges of this mutual assimilation and response.

In Patrick's writings philosophical enquiry is carved into the thickness of lexical exploration, through a restless curiosity and voracious attention to words and their fabric. He shuns any indexical relationship between words and sounds: writing is, listening is. As expanded fields of forces sometimes they repel, sometimes invite you in. Echoes of other worlds animate them, *unable to cease to be*.

* * *

Lydgalleriet, Bergen, Norway, 29 June 2014

I enter the small dark room as Karen Skog and John Hegre are playing. Entering the black room built within the gallery, transitioning from the open space and the bright Nordic summer light of Bergen into the black room makes the shift in scale even more dramatic. I find Norwegian artists Skog and Hegre intent at playing an array of instruments; their backs to me, I can barely see their faces, rather I can guess movements and hear sounds, long drones emitted from a theremin, a violin, a harmonium, pedal effects and other devices. They unravel slowly and create a state of loaded uneventfulness, occasionally disturbed by electric bursts of noise.

In the dark box Skog and Hegre are two apparitions, whose movements in the dim light are dictated by the urgency of the sounds they emanate. Many threads are at play—I'd noticed

some of them on entering the gallery, I'd seen drawings, pieces of wood, I'd read the name Aby Warburg somewhere, and a hint at the art of memory on the cover of a book elsewhere. In the dark box I listen and stay, engaging with a sustained reflection on memory as a transformation of presence rather than a reversal to origins. I transit back into the light and I hear another layer of sounds, recorded in the black box the previous day and played back into the white room, to reinstate once more a thread of circular thoughts around sounds broken, adjusted, stitched and recurring. No announcement framed the sound performance, no text or guide seeks to explain what is going on in the space. I see lists of materials, diagrams, instruments, pencils, rice paper, notebooks, rulers, threads; all setting up a room to be constructed, drawn, disassembled and erased and recalled every other day—like sound.

In the space configured by Skog and Hegre I listen and make connections (which does not always equal harmony but also incoherence, frustration and waste of time). I find no claims for eventfulness, rather a quiet zone for thinking that bears stillness and unfolding, reflected in the slow drones that at times meet, at times clash with the sounds recorded the previous day.

I later read a statement by the show's curator, Signe Lidén, observing that the space of the gallery was transformed by Skog and Hegre into the space of a public library, allowing reading to envelop listening, research and encounter, trial and error, thoughts meandering rather than concluded. Perhaps their final appeal is for us to cease to aim at being clear and distinct.

* * *

Swedenborg House, London, 9 April 2014

David Toop is playing vinyl records in penumbra, sounds tapping and humming in slow compelling rhythms, soft percussion, breaths and chants and clustered beats. Spectral spell

listening in penumbra, thoughts moving around sounds tapping with a few echoing thuds.

Listen to the recordead.

He does not make any comments on these sounds, he does not speak but he seems to be diffusing an impression of one of the many universes of sounds he's been listening to, inhabiting and shaping across the years. He plays records in this room, we listen and there is no context or background, codes or canons other than our own, feeble as they might be. The illusion of collective listening is splintered into individual channels of understanding, where *collective* is more pertinent to being in a room than to a shared response to the sounds—each of us absorbed in our personal responses that are contingent and dissimilar, even from our own selves, even more so because we're devoid of further knowledge or information attached to the recordings—hence we can only attach more individual thoughts to them, maybe later talk about them.

Often the act of listening is mistaken with paying attention exclusively, whereas it so often also involves inclusion, mishaps, chance, distraction, not always alert states of mind, indeed deaths and metamorphoses: between waste and intensity, time. In this room tonight I see how the time spent listening flows back as pockets of intensities handed over to more listeners: for these forty minutes of sounds to unravel as profoundly as they do, it will have not taken forty minutes, but a lifetime attending to, thinking, playing, spending and wasting time with these sounds and again, encountering in turn illuminating thoughts and actions, puzzling ones, revealing and obscuring, engaging and drifting. This is not a commentary on a motionless recorded past to be preserved and archived: this is a prompt to follow on in listening, to change, to know what can be meaningful even if it is useless as it is made meaningful through presence.

The question with these sounds is not *what are these?* but *who is here?* and *how?* —not only in person, but in memory. The absent presence of sound, that David writes of in *Sinister Resonance,* does not call for fixed genealogies, but for a reinstatement of such presence in passing. This point is crucial, especially if set against conventional formats of discussions and presentations of *sound,* where sound becomes an apology, where lecturers and scholars awkwardly and unsuccessfully try to squeeze four chapters of a book in fifteen uneasy minutes through rushed readings of powerpoints, bullet points. To listen is not about points, sometimes it has no point either, certainly it shoots no bullets—it is a flux of presence, and this is what we get tonight as David does not drown us in display of knowledge but offers sounds to listen to and be with, now, in this room, for all the fullness or bedazzlement or exhilaration or strangeness experienced now, in this room, with no need for references or footnotes but absorbed in what we can hear now, in this room, and this room and now mean the intricate threads of understanding that we weave and undo in life.

In a text that covers the evening with yet another layer of obscurity, with no claims for explanation, David quotes Dorothy Miller Richardson's words in *The Tunnel* (1919): *The lecturing voice was far away, irrelevant and unintelligible. Peace flooded her.* To subtract the lecturing voice, to merge one's presence with the room's seems a recurring course of action in all of Toop's latest activities—for example the insistent brushing against the surface of his musical instruments, inaudible but intent, unheard but present, a few days earlier at one of the *Sculpture* performances that he's been setting up with Rie Nakajima since 2013; or the *Sharpen Your Needles* evening at Café Oto the following month, playing vinyl records with Evan Parker, not for the sake of displaying a collection of obscure music, but to play it and *not* lecture about it—to let sound be presence rather than the customary annoying wordy absence too often encountered in

soundless conferences and lectures on sound. These activities do not point at an unattainable knowledge: a possible knowledge is built in the space of listening, frayed, never complete but always present in change.

Toop staged his listening event at the Swedenborg House in London. Back home I try to listen to Swedenborg across my library. I find Walt Whitman, *and I the apparition, I the spectre*; I find August Strindberg, *this is the book of the great disorder and of the infinite coherence*: *Inferno*, a book generated by the reading of Swedenborg, extracted from diaries of a circling obsession, beginnings that end at the beginning. Most of all I find Ralph Waldo Emerson, who in his essay *Swedenborg; or, the Mystic* (1850) wrote the words that I need to close this text: *...these evanescing images of thought. True in transition, they become false if fixed.*

15.

LISTEN

Letters

or,

a version of the previous arguments from the minor angle, the less outspoken, to be whispered, by the whisperer

or,

a glimpse into my writing behind the scenes,

from notes written on scraps of paper and on notes on an iPhone then lost and recalled in a lopsided way

longing for, attempting at a writing lost at sea

like Bas Jan Ader in search of the miraculous lost toward the horizon of an ocean

and again I encounter borders of my self

again I think of the horizon in Melville's late short story *Daniel Orme*, Daniel the sailor landlocked and looking at the horizon.

Daniel Orme

Daniel, or me?

Daniel a letter lost

and always a letter gained: in the UK people often spell my name as *Daniella*, I gain one L, a letter lost a letter gained, an A and an L—which amuses me, first because it makes my name sound a bit like a joke, where *ella* in the first name rhymes comically with *ella* in the surname (in Italian, the double l accelerates the way you pronounce a word, whereas the pace in *ela* is much slower and opens backwards toward the E); and secondly it amuses me because it makes me think, ah, L is listening, there you go, the gift you get from this added L to your name really wants you to find some meaning in it, a bit like that famous bullet with one's name written on it, L is the bullet with the surplus of my name written on it and is bound to strike me.

...

A lead-coloured blanket crept up toward the edge of the sky and darkened it, in restless flickers of anthracite shading. It gradually thinned down and shaped itself into a word, I could read each letter one by one, in capital letters the word was

LISTEN

...and the letter type was exactly the same one that appears in the poster of Max Neuhaus' renowned performance from 1976. In my sound-art nightmare, the letters began to peel off the sky and fall on the ground, some of them denting the soil, others caught in tree branches, or cracking roofs, others splashing in the river, others shot like silver bullets ready to tear off my ears. Some of them looked like they were ducking off the edges of buildings to disappear. Others stood still, big and threatening. I followed them one by one:

L , I , S , T , E , N .

L sounds the Italian word *lontano,* away, far away, L is away, listen and listening, *lontanando,* L as in La, in Italian La is the musical note A, the note you use to tune an instrument, a beginning, at the beginning L landslides loops loiters laps lingers and at last L leaks through the walls of a library and lands, alphabetically observant, on an open book by Leopardi, Giacomo Leopardi the Italian Romantic poet who once wrote a poem looking at a hedge on a solitary hill, listening to the wind rustling through leaves meditating on the passing of time, and infinite silence. L lands on the open book by Leopardi and sticks onto the first letter of another of his poems, *La sera del dì di festa* (*The Evening of the Holiday,* 1826). I read some verses: *E fieramente mi si stringe il core, a pensar come tutto al mondo passa, e quasi orma non lascia. And it grips my heart fiercely, to think how all in the world passes, and nearly leaves no trace.*

I want to linger on that *quasi, nearly: All in the world passes, and nearly leaves no trace. Nearly.* And yet, a trace it leaves in its passing, this all. The same heartache the poet got at the thought of things passing in the world arises as he recalls the echo of a song, *lontanando,* as it dies little by little, crushing his heart. *Un canto lontanando morire a poco a poco / già similmente mi stringeva il core.*

Like Villiers de l'Isle-Adam's fictional Thomas Edison in his 1886 book *Tomorrow's Eve,* who mourns the loss of all the sounds from the past that he missed the chance to record before he invented the phonograph, and yet sounds them in the telling wonders of his imagination and words, Leopardi wonders about, and writes, the cries of his ancestors in Rome, the clash of weapons across land and sea, the lost sounds of conflict and war. In the night of the holiday all is peace and silence, the world is resting, and so are sounds except for those of memory. The L in listening is away, *lontano,* it prompts resounding memories from afar. How far back, in time?

I is *Ice Age Art*, the title of an exhibition I visited in March 2013 at the British Museum. I see *The Lion Man*, from the Stadel Cave in the Hohlenstein mountain, an ivory sculpture dating to around 40,000 years ago. It presents a man with a lion's head. I cannot even figure the meaning of 40,000 years ago, in time it is abstract, in matter it is close. The fascination with those objects is: there is hardly any knowledge of what their function was. Better then to stop thinking about function altogether, and focus on the pull toward them, instead of the reason of that pull. In a series of lectures following the discovery of the Lascaux cave in 1940, Georges Bataille makes crucial points about our fascination with primitive art, art from afar: we cannot even start to connect with these artefacts, he says, if we wonder about function or artistic intentions. He urges to consider the feeling of their *burning, fiery presence*. Now, today. Such apparitions do not designate *this* or *that* as a thing, but the tactile motions and the feelings of those who made them. The execution of the carving was part of a ritual of evocation/apparition, the resulting objects did not have *meanings as permanent figures*. Keepers of what is forgotten and hardly possible, once they are displayed they are misread as representations of something lost, their materiality is mistaken for beauty, authenticity, origin. What gives them such charm though is the negation of their durability. As they reach out to us across the millennia as objects, they merge the confusion of a past with the clear evidence of how every present is endlessly relayed unto us in metamorphosis, endlessly changing yet familiar. Perhaps their final appeal is for us to cease to aim at being *clear and distinct*.

S its head and tail identical and opposite, a long sibilant succession of words, Sybil Siluetas Silence Silurian Sculpting Sounding Senses Sbarbaro.

At the beginning of the 20th century the Italian poet Camillo Sbarbaro wrote broken verses of small utterances. He also collected lichens. Often he would write of his words becoming mineral, and himself mineral, too. At the end of the thirties he wrote, in a collection of fragments called *Wood Shavings*:

> *What remained inside me of what I'd felt, was what is left of a whispering; something incredible, which I seemed to 'hear through'; the wonder it gave me dwells on. And if that place is vague to the memory, as the place pointed at by the Sybil's words, then the fear of not capturing the place sharpened my yearning.*

I want to dwell in this state of sharpened yearning and *hearing through*, and write of caves and of Sybil's words; to dwell in these transitions between being in a place and the premonition of my absence, not being able to hold sounds, between records of sounds and their metamorphoses in listening.

Ana Mendieta in the seventies, echoed such resounding absence in one of her *Siluetas*, when she outlined her figure in mud at the entrance of a cave, in a space initially carved out by an animal. Can I cover my words in mud like Mendieta, at once be present and echoing cavity within cavity? What do I make of all these trips to the catacombs of my self? Forty years after Mendieta, the dimension of that silence and absence still resounds, and now I think of storing it, in amalgams of words: *this* is how I build my language.

* * *

On returning from the cave, Sbarbaro writes of the Sybil. A cave, an abyss, a Sybil also animate a poem that I always enjoy reading

aloud, it's entitled *Spelt from Sybil's Leaves* (1918), it was written by Gerard Manley Hopkins, it moves across cavernous spaces, black, words falling from the skies, lost words and broken utterance, and I have nothing more to say to you about this poem which is so close to what I want to say. I'd rather let its words break into mine.

EARNEST, earthless, equal, attuneable, ' vaulty, voluminous, ... stupendous

 Evening strains to be tíme's vást, ' womb-of-all, home-of-all, hearse-of-all night.

 Her fond yellow hornlight wound to the west, ' her wild hollow hoarlight hung to the height

 Waste; her earliest stars, earl-stars, ' stárs principal, overbend us,

 Fíre-féaturing heaven. For earth ' her being has unbound, her dapple is at an end, as-

 tray or aswarm, all throughther, in throngs; ' self ín self steedèd and páshed—quite

 Disremembering, dísmémbering ' áll now. Heart, you round me right

 With: Óur évening is over us; óur night ' whélms, whélms, ánd will end us.

 Only the beak-leaved boughs dragonish ' damask the tool-smooth bleak light; black,

 Ever so black on it. Óur tale, O óur oracle! ' Lét life, wáned, ah lét life wind

 Off hér once skéined stained véined variety ' upon, áll on twó spools; párt, pen, pack

 Now her áll in twó flocks, twó folds—black, white; ' right, wrong; reckon but, reck but, mind

 But thése two; wáre of a wórld where bút these ' twó tell, each off the óther; of a rack

 Where, selfwrung, selfstrung, sheathe- and shelterless, ' thóughts agaínst thoughts ín groans grínd.

There were times when, walking along the river or lost in the evening traffic, it might have happened that she would think to be, in her very own peculiar way, listening: moments of inner fulfilment with no proximity of friends or lovers. It was the city itself, its cold air maybe, that brought about this type of extremely absorbed sensation, it was the city too that managed, for a handful of moments, to yield some sort of illuminations like for example that day when she was awakened to the presence of the light by the twitter of house-martins, she'd always found their twittering so different, mechanical nearly, like sounds from a game arcade. That artificial sound had something about it at once tingling and concluded, tingling in feel and concluded in shape like the feather she'd been thinking of a few days back. It was also eaten up by the wind and the rustling of tree leaves around, so, rather than asserting permanence it hinted at an unfolding and a vanishing. Everything on those moments seemed to be drawn together and reveal its shape: the landscape of the city became like a scenery cut away from time, and in this otherness she passed on. One evening as she walked back home, the setting sun against the third-floor window of the red brick house at the edge of the heath flashed a surface of full-on orangey red, deep and shimmering, like the inmost light shining out of the window in a long-forgotten tale by Arthur Machen. What darkness was hiding in that red, what screams? A window and only that window, so for a few moments she seemed to be embroiled in a very special connection with that panel of glass and that reflecting light, as if her whole day had existed for that moment to happen and for her to be there, to see that red against a sky of greenish and dirty pink, veined of pearl like the background of a 17th-century Spanish painting, its flatness unevenly rippled by those veins of pearl. Unnervingly receptive after the day-long walk, everything seemed to leave a deeper impression on her: the beat and crashing echo of thoughts like tall breakers against a stone pier. Then she could listen to: all echoes, all beats, circling like a chant

inside her head, realising at the end that she had come across exactly nothing, and that nothing mattered. Just like the circling empty thoughts that repeatedly hammered her teenager-brain against books read and books remembered and void, that terror of void after reading and reading so many books and listening to all their voices but then, how to write?

E echoes escape and ephemeral. Louis Aragon on the ephemeral: *Ephemeral. F.M.R.L. (frenzy-madness-reverie-love), a fame really, ever merrily, Effie marry Lee: there are words that are mirrors, optical lakes toward which hands stretch out in vain. Prophetic syllables.* Think of the fragility of early recordings, so close to breaking up, always on the brim between keeping and vanishing. Think of the ever-growing collections of digital audio archives, aural *Wunderkammern* so big in their scale that they clash against any measure of human time, and roll back into the impossibility of holding listening. Think of the friction between object and passing, embodied in recorded sounds. The elusive sound object that Pierre Schaeffer struggled to define, as he kept orbiting around it with his words, when in his tormented journals *In Search for a Concrete Music* (1952) he wrote: *The sound object doesn't say much, and certainly not what we would like it to say. Once we have heard it, it makes us fall silent. In this silence we perceive new disturbances... The secret sound penetrates us, extending into profoundly hidden realms beyond.* Then, I think, writing must follow up all this. I don't want to fall silent, I want my words to reach out into those disturbing and profoundly hidden realms beyond, those caves — like rearrangements of Aragon's prophetic syllables, a sonorous nothing, a stuttering reverb. Each cluster of words is not created anew but cast from words that were before, recalled from archival layers. I don't want to explain them, but rearrange them and hand them over to you before they expire.

* * *

Sometime in the stiff dance of these alphabet letters I drift, absent-minded along broken lines.

* * *

Now the letters that form LISTEN arrange and echo themselves repeatedly in a line, it looks like the edge of a world, out of which I could flip over toward elsewhere.

N is in its sound enchanted. It seems fitting at the end of listen-en, en stuck on a groove, listen, en, en, enchanted. Like in the tale of the enchanted child.

* * *

The Tale of the Enchanted Child

The enchanted child went outside in the world and was struck by countless wonders. She did not know how, but soon she found out she could not speak but had the ability to transform sounds into objects and materials.

And so it happened, that in a frayed piece of thin fabric she transformed the thin rustle of Italian oak leaves in the summer. Slightly out-of-tune voices singing in a church were edged over into minerals the names of angelite, galena, volborthite, sapphire. In a splinter of glass, she kept the thumping march of a lost ship disappearing in a harbour at dusk.

Every day she distilled the subtlest of sounds and sublimated them in phials and essences: the call of the barking dog in the middle of a summer night in a Mediterranean country. The first time she heard a woodpecker drumming. The stubborn uneven clank of footsteps, as she listened to the two-noted clack-clacking tune of wooden clogs.

She went on day by day, little by little, and subtracted and transformed sounds from her world, until there was nothing more to hear, and she fainted, cold, in the middle of all her most precious, perfect, still, yet no longer resounding things.

Perhaps their final appeal is for us to cease to aim at being *clear and distinct*.

* * *

The enchanted child awakens in the hospital,
or,
My sound art nightmare of Henri Michaux.

The noise is atrocious. They have given me a room in the hospital at some distance from the others.

I share it with a coughing woman.

I'm not sure I can speak. Certainly I can scream. Certainly she can cough.

She coughs in two-step, uneven beats, like a diseased pendulum tolling into this void chamber. To counter the coughs and to counter the time of the pendulum, I let myself give in to the screams of my infernal suffering that I can now only hold back with extreme difficulty but whose overflow is imminent, if it has not already been reached.

But why, oh why did they give me this diseasedpendulum-coughingwoman, who lacerates my rare moments of peace and is shredding to pieces, disastrously, the little continuity I can manage to keep, in this terrible harassment of pain? One and two, one and two, each uneven pair of coughs stirs and pokes, pokes my sleep and my hearing, and it probes and provokes my screams. Away! I have to find a way out of this. It seems that there is no ceiling in this room, up there on the vault of the sky I see shadows that nobody projects; earnest, earthless, equal, attuneable, vaulty, voluminous… stupendous evening strains to be time's vast womb-of-all, home-of-all, hearse-of-all night. Below, I hear the rumble of an earthquake. The room is shaken by the hits of the two deep throaty dissonant notes of the pendulum woman, Our Lady of Dissonance, Our Lady of Disease. A lead-coloured blanket creeps up toward the edge of the sky and darkens it, in restless flickers of anthracite shading. It thins down and shapes itself into a word, in capital letters the word is LISTEN, I think I can hear it now, LIST-TEN, LIS-TEN, LIS-TEN, it is not outside but here, two syllables coughed out of

my restless time, coughed out into my lack of proper speech and into the totality of my scream: am I hearing or screaming, is the coughing now coming from my throat? The letters begin to peel off the sky and fall on the ground, one of them denting the soil, another caught in tree branches, or cracking roofs, another splashing in the river. The final two are shot like silver bullets ready to tear off my ears. To tear off my ears, LIST-EN. To tear off my ears, LIST-EN, to tear off my ears, list-en, to tear off my ear, list-en, to tear off my ears.... LIS-TEN, but these two syllables, but these two, ware of a world where but these two tell, each off the other, of a rack where / self wrung, selfstrung, sheathe- and shelterless, thoughts against thoughts in groans grind.

References and Credits

Quotes in the book appear in italics, either embedded in the text or as block quotations. All quotes are given credit in the following pages.

Translations of short excerpts from Italian books are mine, unless noted otherwise.

Words page

Aragon, Louis, *Paris Peasant*, tr. Simon Watson Taylor (Exact Change, 1994), 91.

Strindberg, August, *Inferno*, tr. Luciano Codignola (Milano: Adelphi, 2000), 46.

Toop, David, *Sinister Resonance: The Mediumship of the Listener* (New York and London: Continuum, 2010), 48.

Voegelin, Salomé, *Sonic Possible Worlds. Hearing the Continuum of Sound* (New York and London: Bloomsbury, 2014), 2.

The Enigma of Kaspar Hauser, Werner Herzog, dir. (1974).

1.

Dialogue of Sound and a Writer was commissioned and first published by Akerman Daly for *Flash 500* on akermandaly. com in 2013.

The dialogue was inspired by Manganelli, Giorgio, *Le interviste impossibili* (Milan: Adelphi, 1997).

2.

Michaux, Henri, 'On Music, from *First Impressions, 1949*', in *Darkness Moves. An Henri Michaux Anthology: 1927-1984*, ed. and tr. David Ball (Berkeley, Los Angeles and London: University of California Press, 1997), 321.

Scelsi, Giacinto, *5 String Quartets, String Trio, Khoom* (Paris: Naive Montaigne, 2002) [2xCD].

Scelsi, *The Orchestral Works 2. La nascita del verbo, Quattro pezzi (su una nota sola), Uaxuctum* (New York: Mode Records, 2007) [CD].

Michaux (1997), 326.

Scelsi, *L'homme du son* (Arles and Paris: Actes Sud, 2006), 228.

3.

Dark, the Dim Hear is part of a series of texts commissioned by Nathaniel Robin Mann for the *Resonant Voices* event, Pitt Rivers Museum, Oxford, 19 March 2014.

4.

Cornford, Stephen, *Music for Earbuds* (3Leaves, 2013) [CD].

5.

This text was prompted by a series of conversations and email exchanges between Bergen and London with Signe Lidén.

Arendt, Hannah, 'Walter Benjamin: 1892-1940', in Walter Benjamin, *Illuminations: Essays and Reflections* (New York: Schocken Books, 1969), 51.

Smithson, Robert, 'Incidents of Mirror. Travel in the Yucatan, 1969', in *Robert Smithson: The Collected Writings*, ed. Jack Flam (Berkeley, Los Angeles and London: California University Press, 1996), 133.

Ana Mendieta: Traces, ed. Stephanie Rosenthal (London: Hayward Publishing, 2013).

Bataille, Georges, 'The Passage from Animal to Man and the Birth of Art', in *The Cradle of Humanity: Prehistoric Art and Culture*, tr. Michelle and Stuart Kendall (New York: Zone Books, 2005), 57-80.

Sebald, W.G., 'J'aurais voulu que ce lac eut été l'Océan…', in *A Place in the Country*, tr. Jo Catling (London: Hamish Hamilton, 2013), 57.

Aragon (1994), 91, 70.

'London is now veiled, now vanished, now crumbled, now fallen.' Woolf, Virginia, *The Waves* (Oxford: Oxford University Press, 1992), 48.

6.

An earlier version of *Borders*, accompanied by film clips and audio samples, was presented at *Points of Listening 6* curated by Mark Peter Wright and Salomé Voegelin, London, LCC, 18 June 2014.

von Hoffmansthal, Hugo, *The Letter of Lord Chandos*, http://depts.washington.edu/vienna/documents/Hofmannsthal/Hofmannsthal_Chandos.htm [accessed 11 August 2014].

Césaire, Aimé, 'Notebook of a Return to the Native Land', in *The Collected Poetry*, tr. Clayton Eshleman and Annette Smith (Berkeley, Los Angeles and London: University of California Press, 1983), 55.

Kiss Me Deadly, Robert Aldrich, dir. (1955).

Hush, Hush, Sweet Charlotte, Robert Aldrich, dir. (1964).

Paris, Texas, Wim Wenders, dir. (1984).

The section beginning as *The voice, recorded and transmitted...* is the reworking of a text previously published in *Ursula Nistrup. Eavesdropping*, Cecilia Canziani, ed. (Rome: Cura, 2014).

Lost Highway, David Lynch, dir. (1997).

Beckett, Samuel, *The Unnamable* (London: Faber and Faber, 2010), 127.

Janet, Pierre, 'Les sentiments du vide' and 'Les délires du vide et les états de vide', in *De l'angoisse à l'extase. Études sur les croyances et les sentiments*, Vol. II (Paris: Société Pierre Janet et Laboratoire de Psychologie Pathologique de la Sorbonne, 1975).

De Martino, Ernesto, *La fine del mondo* (Torino: Bibioteca Einaudi, 1977).

Lispector, Clarice, *Água viva*, tr. Stefan Tobler (London: Penguin, 2014), 20, 21, 6.

Tenores di Bitti, *Intonos* (Robi Droli, 1994) [CD].

Cascella, Daniela, 'Arthur Russell: Wild Combination', *Blow Up*, 106 (2007).

Whitman, Walt, 'The Unexpress'd', in *Leaves of Grass* (New York: Signet Classics, 1980), 415.

Throne of Blood, Akira Kurosawa, dir. (1957).

7.

This chapter is an echo of 'Book 1: Beginnings: Chapter 1' in Duncan, Robert, *The H.D. Book (The Collected Writings of Robert Duncan)*, (Berkeley, Los Angeles and London: University of California Press, 2012) [Kindle ebook], loc. 2340 and 2485/15428.

Sebald (2013), 166.

Russell, Arthur, 'Home Away From Home', in *Another Thought* (Point Music, 1994) [CD].

Leiris, Michel, *L'Afrique fantôme* (Paris: Gallimard, 1981).

Cascella, *En Abîme. Listening, Reading, Writing. An Archival Fiction* (Hants: Zer0 Books, 2012).

8.

Pound, Ezra, 'Canto 81', in *Cantos*, http://www.poetryfoundation.org/poem/241054 [accessed 11 August 2014].

Rhys, Jean, *Wide Sargasso Sea* (London, Penguin, 1968).

Desnos, Robert, 'Journal d'une apparition', *La révolution surréaliste*, 9/10 (October 1927).

Dickinson, Emily, 'I Felt a Funeral in My Brain', in *Collected Poems of Emily Dickinson* (New York: Gramercy Books, 1982), 230.

Schönberg, Arnold, 'Il rapporto con il testo', in Kandinsky, Wassily and Marc, Franz, eds., *Il cavaliere azzurro*, tr. Giuseppina Gozzini Calzecchi Onesti (Milano: SE, 1988), 55-65.

Ferrari, Luc [website], http://www.lucferrari.org/download/discographie/jetzt.pdf [accessed 12 October 2012].

9.

Machen, Arthur, 'The Inmost Light', in *The Three Impostors and Other Stories. The Best Weird Tales of Arthur Machen, Vol. 1* (Hayward: Chaosium Books, 2007), 77.

Le notti di Cabiria, Federico Fellini, dir. (1957).

Breaking the Waves, Lars von Trier, dir. (1996).

Almamegretta, 'Gramigna', in *Sanacore* (CNI, 1995) [CD].

Dark Habits, Pedro Almodóvar, dir. (1983).

Gide, André, *Marshlands and Prometheus Misbound. Two Satires*, tr. George D. Painter (London: Secker & Warburg, 1953), 15.

The description of the visit to the Rio Martino cave is a new version of an excerpt from Cascella, 'Recollections', in *Paolo Inverni: Paths*, artist's edition and exhibition catalogue (Berlin: Galerie Mazzoli, 2009).

10.

This text was first published on *Wolf Notes #7*, 'Representation', Patrick Farmer and Sarah Hughes, eds. (Compost and Height, 2014), http://wolfnotes.wordpress.com/wolf-notes/ [accessed 23 July 2014].

It is a reflection written after *Sculpture 2*, curated by David Toop and Rie Nakajima, London, Dalston House/Café Oto, 11 July 2013.

Rolf Julius. Small Music (Grau), Bernd Schulz and Hans Gercke, eds. (Heidelberg: Kehrer Verlag, 1995), 38.

11.

Partch, Harry, 'Thoughts Before and After *The Bewitched*, 1955', in *Bitter Music. Collected Journals, Essays, Introductions, and Librettos* (Urbana and Chicago: University of Illinois Press, 1991), 238.

Rilke, Rainer Maria, *Rodin*, tr. Claudio Groff (Milano: SE, 1985), 32.

Rodin, Auguste, *Meditation*, http://collections.vam.ac.uk/item/O135947/inner-voice-the-muse-figure-rodin/ [accessed 18 February 2013].

Baudelaire, Charles, 'La Beauté', in *I fiori del male* (Milano: Feltrinelli, 1999), 36.

Hugo, Victor, 'Préface, 24 juin 1837', in *Voix intérieures* [Apple ebook], loc. 26/41.

Jonke, Gert, *Awakening to the Great Sleep War*, tr. Jean M. Snook (Champaign, London and Dublin: Dalkey Archive Press, 2012), 11-12.

Gadda, Carlo Emilio, *La cognizione del dolore* (Milano: Garzanti, 1997).

Russell (1994).

Kiss Me Deadly (1955).

De Filippo, Eduardo, 'Le voci di dentro', in *Cantata dei giorni dispari I* (Torino: Einaudi Teatro, 1995), 379-438.

Malaparte, Curzio, *The Skin*, tr. David Moore (New York: New York Review Books, 2013), 143, 64, 65, 73, 260, 264, 265.

Dante, *Inferno*, Canto III, www.danteonline.it [accessed 11 August 2014].

Gautier, Théophile, 'Iettatura', in *Racconti fantastici*, tr. Elina Klersy Imberciadori (Milano: Garzanti, 1993), 273-366.

Zielinski, Siegfried, 'Magic and Experiment: Giovan Battista della Porta', in *Deep Time of the Media. Toward an Archaeology of Seeing and Hearing by Technical Means*, tr. Gloria Custance (Cambridge and London: The MIT Press, 2006), 57-99.

Capuana, Luigi, Benedetto Croce, Salvatore Di Giacomo and Matilde Serao, *E parve castigo del cielo. Voci di fine Ottocento sul Principe di Sansevero e il suo palazzo*, Fiammetta Rutoli, ed. (Napoli: Alos, 2003).

Weiss, Allen S., 'The Rhetoric of Interruption', originally presented as 'La rhétorique de l'interruption' in the colloquium *Luis Buñuel* organised by *La Revue Parlée* and Jean-Michel Bouhours, Centre Georges Pompidou, Paris, 24 May 2000.

12.

Leiris (1981).

Clifford, James, *The Predicament of Culture. Twentieth-Century Ethnography, Literature, and Art* (Cambridge and London: Harvard University Press), 167, 168, 172.

Leiris, *Rules of the Game, Volume I: Scratches*, tr. Lydia Davis (Baltimore and London: The Johns Hopkins University Press, 1997), 237-8.

Melville, Herman, *Pierre, or, The Ambiguities* (London: Penguin, 1996), 70, 285.

Davis, Lydia, 'The Problem in Summarizing Blanchot', in *Proust, Blanchot and a Woman in Red* (London: Sylph Editions, and Paris: The American University of Paris, 2007), 31.

Sebald (2013), 128.

Feld, Steven, *Sound and Sentiment. Birds, Weeping, Poetics, and Song in Kaluli Expression*, 3rd ed., (Durham and London: Duke University Press, 2012), 45.

Dante, *Inferno*, Canto XIII, www.danteonline.it [accessed 11 August 2014].

Leiris (1997), 14.

13.

Beyond the Object was an event at Central St. Martins, London, 12 April 2014, as part of the *Offering Rites* series curated by David Toop.

Lispector (2014), 78-9.

Jonke (2012), 152-3.

d'Espezel, Pierre, quoted in Hollier, Dennis, 'The Use-Value of the Impossible', in *October*, Vol. 60 (Spring 1992), 4.

Nabokov, Vladimir, 'Lance', in *Collected Stories* (London: Penguin, 2010), 733.

Leiris (1997), 218.

Machen (2007), 74.

14.

Rodari, Gianni, *Lamberto, Lamberto, Lamberto,* tr. Anthony Shugaar (Brooklyn and London: Melville House, 2011).

Brighton Rock, John Boulting, dir. (1947).

Greene, Graham, *Brighton Rock* (London: Vintage Books, 2010), 264.

Dworkin, Craig, email to the author, 11 April 2014.

Lispector (2014), 6, 15.

Argan, Giulio Carlo, *Storia dell'Arte Italiana,* vol. II (Firenze: Sansoni, 1988), 224-5.

Jonke (2012).

Farmer, Patrick, *try i bark* (Compost and Height / London: Organised Music From Thessaloniki, 2012).

Skog and Hegre at Work, exhibition curated by Signe Lidén as part of the Lydhort series, Bergen, Lydgalleriet, 7-29 June 2014.

David Toop, 'Magic and Loss (after Lou Reed). A Listening Event for Magical Objects and Ancestral Sounds', London, Swedenborg House, 9 April 2014, as part of *Points of Listening*.

Whitman (1980), 'Pensive and Faltering', 350.

Strindberg (2000).

Emerson, Ralph Waldo, 'Swedenborg, or The Mystic', in *Representative Men* (1950), www.emersoncentral.com [accessed 9 April 2014].

15.

Melville, 'Daniel Orme', in *Billy Budd, Sailor and Other Stories* (London: Penguin, 1985), 413-17.

Leopardi, Giacomo, 'La sera del dì di festa' in *Canti,* http://www.leopardi.it/canti13.php [accessed 11 August 2014].

Villiers de l'Isle-Adam, *Tomorrow's Eve,* tr. Robert Martin Adams (Champaign: University of Illinois Press, 2001).

Ice Age Art, exhibition, London, The British Museum, 7 Feb-2 Jun 2013.

Bataille (2005).

Sbarbaro, Camillo, *L'opera in versi e in prosa* (Milano: Garzanti/Vanni Scheiwiller, 1985), 413.

Ana Mendieta: Traces (2013).

Hopkins, Gerard Manley, 'Spelt From Sibyl's Leaves', in *Selected Prose and Poems* (London: Penguin, 1953), 59.

Aragon (1994), 91.

Schaeffer, Pierre, *In Search of A Concrete Music*, tr. Christine North and John Dack (Berkeley, Los Angeles and London: University of California Press, 2012), 165.

The Tale of the Enchanted Child is a variation of a short text of Sbarbaro, 'Scampoli I' (1985), 183 and *The Enchanted Child Awakens in the Hospital* is a variation and fugue from Michaux, 'In the Hospital, from *Ordeals, Exorcisms, 1945*' (1997), 93.

Selected Bibliography and Further Reading

Acker, Kathy, 'My Death My Life by Pier Paolo Pasolini', in *Literal Madness: 3 Novels* (New York: Grove Press, 1987), 171-393.

Ana Mendieta: Traces, ed. Stephanie Rosenthal (London: Hayward Publishing, 2013).

Aragon, Louis, *Paris Peasant,* tr. Simon Watson Taylor (Exact Change, 1994).

Arendt, Hannah, 'Walter Benjamin: 1892-1940', in Benjamin, Walter, *Illuminations: Essays and Reflections* (New York: Schocken Books, 1969).

Ashbery, John, *Other Traditions* (Cambridge and London: Harvard University Press, 2001).

Bataille, Georges, *The Cradle of Humanity: Prehistoric Art and Culture,* tr. Michelle and Stuart Kendall (New York: Zone Books, 2005).

Beckett, Samuel, *The Unnamable* (London: Faber and Faber, 2010).

Benjamin, Walter, *The Arcades Project,* tr. Howard Eiland and Kevin McLaughlin (Cambridge and London: The Belknap Press of Harvard University Press, 2002).

Breton, André, *Nadja,* tr. Richard Howard (London: Penguin, 1999).

Calasso, Roberto, *La folie Baudelaire* (Milano: Adelphi, 2008).

Capuana, Luigi, Benedetto Croce, Salvatore Di Giacomo and Matilde Serao, *E parve castigo del cielo. Voci di fine Ottocento sul Principe di Sansevero e il suo palazzo,* Fiammetta Rutoli, ed. (Napoli: Alos, 2003).

Césaire, Aimé, *The Collected Poetry,* tr. Clayton Eshleman and Annette Smith (Berkeley, Los Angeles and London: University of California Press, 1983).

Cixous, Hélène, *Three Steps on the Ladder of Writing,* tr. Sarah Cornell and Susan Sellers (New York: Columbia University Press, 1993).

Clifford, James, *The Predicament of Culture. Twentieth-Century Ethnography, Literature, and Art* (Cambridge and London: Harvard University Press, 1988).

Davis, Lydia, 'The Problem in Summarizing Blanchot', in *Proust, Blanchot and a Woman in Red* (London: Sylph Editions and Paris: The American University of Paris, 2007).

De Filippo, Eduardo, 'Le voci di dentro', in *Cantata dei giorni dispari I* (Torino: Einaudi Teatro, 1995), 379-438.

De Martino, Ernesto, La fine del mondo (Torino: Bibioteca Einaudi, 1977).

Duncan, Robert, *The H.D. Book (The Collected Writings of Robert Duncan)*, (Berkeley, Los Angeles and London: University of California Press, 2012).

Dworkin, Craig, *No Medium* (Cambridge and London: The MIT Press, 2013).

Emerson, Ralph Waldo, 'Swedenborg, or The Mystic', in *Representative Men*, www.emersoncentral.com [accessed 9 April 2014].

Eshun, Kodwo, *More Brilliant Than the Sun. Adventures in Sonic Fiction* (London: Quartet Books, 1998).

Farmer, Patrick, *try i bark* (Compost and Height / London: Organised Music From Thessaloniki, 2012).

Feld, Steven, *Sound and Sentiment. Birds, Weeping, Poetics, and Song in Kaluli Expression*, 3rd ed., (Durham and London: Duke University Press, 2012).

Gadda, Carlo Emilio, *La cognizione del dolore* (Milano: Garzanti, 1997).

Gide, André, *Marshlands and Prometheus Misbound. Two Satires*, tr. George D. Painter (London: Secker & Warburg, 1953).

Greene, Graham, *Brighton Rock* (London: Vintage Books, 2010), 264.

Hugo, Victor, 'Préface, 24 juin 1837', in *Voix intérieures* [Apple ebook].

Janet, Pierre, *De l'angoisse à l'extase. Études sur les croyances et les*

sentiments, Vol. II (Paris: Société Pierre Janet et Laboratoire de Psychologie Pathologique de la Sorbonne, 1975).

Jonke, Gert, *Awakening to the Great Sleep War*, tr. Jean M. Snook (Champaign, London and Dublin: Dalkey Archive Press, 2012).

— *The Distant Sound*, tr. Jean M. Snook (Champaign, London and Dublin: Dalkey Archive Press, 2010).

Kreider, Kristen, *Poetics and Place. The Architecture of Sign, Subjects and Site* (London: I.B.Tauris, 2013).

Leiris, Michel, *L'Afrique fantôme* (Paris: Gallimard, 1981).

— *Rules of the Game, Volume I: Scratches*, tr. Lydia Davis (Baltimore and London: The Johns Hopkins University Press, 1997).

Lispector, Clarice, *Água viva*, tr. Stefan Tobler (London: Penguin, 2014).

Machen, Arthur, 'The Inmost Light', in *The Three Impostors and Other Stories. The Best Weird Tales of Arthur Machen, Vol. 1* (Hayward: Chaosium Books, 2007).

Malaparte, Curzio, *The Skin*, tr. David Moore (New York: New York Review Books, 2013).

Melville, Herman, *Pierre, or, The Ambiguities* (London: Penguin, 1996).

Metcalf, Paul, 'Genoa', in *Collected Works, Vol. I* (Minneapolis: Coffee House Press, 1996), 71-289.

Michaux, Henri, *Darkness Moves. An Henri Michaux Anthology: 1927-1984*, ed. and tr. David Ball (Berkeley, Los Angeles and London: University of California Press, 1997).

Migone, Christof, *Sonic Somatic. Performances of the Unsound Body* (Los Angeles and Berlin: Errant Bodies Press, 2012).

Nabokov, Vladimir, *Collected Stories* (London: Penguin, 2010).

Partch, Harry, *Bitter Music. Collected Journals, Essays, Introductions, and Librettos* (Urbana and Chicago: University of Illinois Press, 1991).

Rhys, Jean, *Wide Sargasso Sea* (London, Penguin, 1968).

Richardson, Dorothy Miller, *Pilgrimage 2: The Tunnel* (London:

Virago Modern Classics, 1992), 11-287.

Rilke, Rainer Maria, *Rodin*, tr. Claudio Groff (Milano: SE, 1985).

Robert Smithson: The Collected Writings, ed. Jack Flam (Berkeley, Los Angeles and London: California University Press, 1996).

Robertson, Lisa, *Nilling. Prose Essays on Noise, Pornography, The Codex, Melancholy, Lucretius, Folds, Cities and Related Aporias* (Toronto: Book Thug, 2012).

Rodari, Gianni, *Lamberto, Lamberto, Lamberto*, tr. Anthony Shugaar (Brooklyn and London: Melville House, 2011).

Roden, Steve, *...I Listen to the Wind That Obliterates My Traces. Music In Vernacular Photographs 1880-1955* (Atlanta: Dust-to-Digital, 2011).

Rolf Julius. Small Music (Grau), Bernd Schulz and Hans Gercke, eds. (Heidelberg: Kehrer Verlag, 1995).

Rosselli, Amelia, *Le Poesie* (Milano: Garzanti, 1997).

Sbarbaro, Camillo, *L'opera in versi e in prosa* (Milano: Garzanti/Vanni Scheiwiller, 1985)

Scelsi, Giacinto *L'homme du son* (Arles and Paris: Actes Sud, 2006).

Schaeffer, Pierre, *In Search of a Concrete Music*, tr. Christine North and John Dack (Berkeley, Los Angeles and London: University of California Press, 2012).

Schönberg, Arnold, 'Il rapporto con il testo', in Kandinsky, Wassily and Marc, Franz, eds., *Il cavaliere azzurro*, tr. Giuseppina Gozzini Calzecchi Onesti (Milano: SE, 1988), 55-65.

Sebald, W.G., *A Place in the Country*, tr. Jo Catling (London: Hamish Hamilton, 2013).

Skelton, Richard, *Landings*, 3rd ed., (Sustain-Release, 2012).

Strindberg, August, *Inferno*, tr. Luciano Codignola (Milano: Adelphi, 2000).

Tondelli, Pier Vittorio, *Opere* (Milano: Bompiani, 2001).

Toop, David, *Exotica. Fabricated Soundscapes in a Real World* (London: Serpent's Tail, 1999).

— *Sinister Resonance: The Mediumship of the Listener* (New York and London: Continuum, 2010).

Ursula Nistrup. Eavesdropping, Cecilia Canziani, ed. (Rome: Cura, 2014).

Villiers de l'Isle-Adam, *Tomorrow's Eve,* tr. Robert Martin Adams (Champaign: University of Illinois Press, 2001).

Voegelin, Salomé, *Listening to Noise and Silence. Towards A Philosophy of Sound Art* (New York and London: Continuum, 2010).

— *Sonic Possible Worlds. Hearing the Continuum of Sound* (New York and London: Bloomsbury, 2014).

von Hoffmanstal, Hugo, *The Letter of Lord Chandos,* http://depts.washington.edu/vienna/documents/Hofmannsthal/Hofmannsthal_Chandos.htm [accessed 11 August 2014].

Weiss, Allen S., *Breathless. Sound Recording, Disembodiment, and The Transformation of Lyrical Nostalgia* (Middletown: Wesleyan University Press, 2002).

Whitman, Walt, *Leaves of Grass* (New York: Signet Classics, 1980).

Woolf, Virginia, *The Waves* (Oxford: Oxford University Press, 1992).

Zielinski, Siegfried, *Deep Time of the Media. Toward an Archaeology of Seeing and Hearing by Technical Means,* tr. Gloria Custance (Cambridge and London: The MIT Press, 2006).

Acknowledgements

This book revisits and interpolates a number of thoughts and texts gathered over three years during and after readings, performances, seminars and events. Thank you Angus Carlyle and Cathy Lane, Aya Kasai, Cecilia Canziani and Ursula Nistrup, Christian Patracchini, Dan Scott and Rebecca Lewin, Eileen Daly and Jeremy Akerman, Jeremy Welsh and Signe Lidén, Julie Lillelien Porter, Mark Peter Wright, Nathaniel Mann, Phil Owen, Sarah Hughes, Stephen Cornford for commissioning texts or for inviting me to read from my work in progress; and thanks also to everyone who attended my readings and responded afterwards.

I would like to thank Richard Skinner and Stefano Scalich for their advice regarding publication.

I would especially like to thank Salomé Voegelin for her support, and for challenging my ideas during many thought-provoking conversations in our *Ora* broadcasts and beyond.

I am grateful to David Toop for reading early versions of some of these texts and for encouraging my writing project; and to David and Rie Nakajima for inviting me to contribute to their *Sculpture* events, giving me the chance to discover new forms of reading, listening and writing.

My gratitude to Patrick Farmer for offering crucial insight into the first draft of the manuscript; and to Basia Lewandowska Cummings for her invaluable editorial input and for her enthusiasm for this project.

I am deeply grateful to the early readers and supporters of this book, Allen S. Weiss, Craig Dworkin, Kristen Kreider for their attention and suggestions, for corresponding and responding.

Thank you Zer0 for publishing this book and for allowing continuity to a project that started with *En Abîme* in 2012.

This book was completed during an Early Career Research Fellowship in the School of Arts at Oxford Brookes University. Thank you Paul Whitty, Ray Lee and Tracey Warr for facilitating my work.

I am indebted to my parents Nina and Vincenzo and to my brother Michele for their unconditional trust and for always keeping spirits up.

Thank you Colin for being ever so close, and for the jigsaw puzzle.

By the Same Author

En Abîme: Listening, Reading, Writing. An Archival Fiction
Zer0 Books, 2012
ISBN 978-1-78099-403-1

I consider Daniela Cascella to be one of the leading theorists and explorers of an exciting new discourse growing up around the practice of listening. Her book is poetic, incisive, grounded in politics and history yet continually pushing at the edges of what we now consider to be sound. She interrogates notions of music and the shifting experience that is silence with a freshness and coherence that is inspiring.
David Toop, author of *Sinister Resonance* (2010), *Haunted Weather* (2004) and *Exotica* (1999)

En Abîme... produces a wonderful séjourne into history that brings with it the contemporary condition of being, remote, apart, unseen, but in constant contact. Its words compose a listening journey that reminds of diaries written before the computer and the internet: crafted by hand, meticulously inscribing every shard of the travellers experience and thought. And so it talks intriguingly about listening to culture and cultural artefacts, not to know about sound but to know about culture, the social, the political and to make you understand rather than know the expanding function of listening.
Salomé Voegelin, author of *Sonic Possible Worlds* (2014) and *Listening to Noise and Silence* (2010)

With the incantatory circularity of a responsorium, Daniela Cascella weaves the threads of sound and life in a tapestry of ringing depths and aching beauty. Cascella plays on the same emotional chords, on the same poetical league as the artists she

draws from: Marini, Melville, Pasolini. And just like in *Pierre*'s recalling and refashioning, she constructs a fresh form out of mutilated remembrances, out of physical and psychological remotednesses: the listener has become a composer.

Luciano Chessa, author of *Luigi Russolo, Futurist* (2012)

Somehow this cascade of disrupted impressions makes sense. I felt at times as if the voice of the late Chris Marker was speaking to me—Cascella has a similar aphoristic style that recalls *Sans Soleil*'s meditations on memory... *En Abîme* is, like Marker's films, a road book, and as in his creations, there is at the end an elusive but firm sense that our world has transformed a little.

Agata Pyzik, *The Wire* (2012)

Cascella shows how sonic experiences become a shivering body, a rhythm that finds parallels in literary, filmic or visual experiences.

Lola San Martín Arbide, *Ethnomusicology Review* (2013)

An inspiring sound-memoir that models a way to listen to sound and write about its aftermaths.

Chris Kennedy, *MusicWorks Magazine* (2013)

Daniela Cascella
www.danielacascella.com
http://enabime.wordpress.com

zero
books

Contemporary culture has eliminated both the concept of the public and the figure of the intellectual. Former public spaces – both physical and cultural – are now either derelict or colonized by advertising. A cretinous anti-intellectualism presides, cheerled by expensively educated hacks in the pay of multinational corporations who reassure their bored readers that there is no need to rouse themselves from their interpassive stupor. The informal censorship internalized and propagated by the cultural workers of late capitalism generates a banal conformity that the propaganda chiefs of Stalinism could only ever have dreamt of imposing. Zer0 Books knows that another kind of discourse – intellectual without being academic, popular without being populist – is not only possible: it is already flourishing, in the regions beyond the striplit malls of so-called mass media and the neurotically bureaucratic halls of the academy. Zer0 is committed to the idea of publishing as a making public of the intellectual. It is convinced that in the unthinking, blandly consensual culture in which we live, critical and engaged theoretical reflection is more important than ever before.